THE ARCHAEOLOGY OF OXFORD IN 20 DIGS

David Radford

AMBERLEY

First published 2018

Amberley Publishing
The Hill, Stroud
Gloucestershire, GL5 4EP

www.amberley-books.com

British Library Cataloguing in Publication Data.
A catalogue record for this book is available from the British Library.

ISBN 978 1 4456 8085 9 (print)
ISBN 978 1 4456 8086 6 (ebook)

Origination by Amberley Publishing.
Printed in Great Britain.

Contents

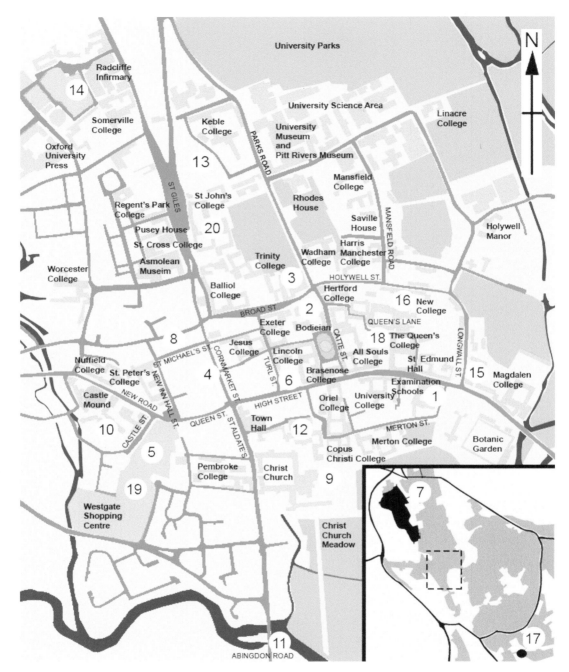

Plan showing the location of the twenty excavations discussed in the book.

PERIOD	TIMELINE
Mesolithic 10,000–4000 BC	• Isolated flint scatters representing temporary camps and working areas.
Neolithic–Early Bronze Age 4000–1500 BC	• Monumental ritual and funerary earthworks are built on the floodplain (the Northmoor terrace) and the Oxford gravel terrace (the Summertown-Radley terrace).
Middle–Late Bronze Age 1500–800 BC	• Isolated burials and other evidence for activity is found on the limestone hills around Oxford. Settlement evidence is very sparse.
Iron Age 800 BC–42 AD	• Extensive landscape of farmsteads and field systems established.
Roman 43–409 AD	• A Romano-British village is established in the vicinity of South Parks Road. Roman roads cross the Oxford gravel terrace. Pottery manufacturing compounds are established in east and south-east Oxford.
Early Saxon 410–600	• New dispersed rural settlements are established, sometimes around existing prehistoric earthworks.
Middle Saxon – Late Saxon 600–1066	• A religious and trading centre develops close to a crossing point over the River Thames. Subsequently Oxford is established as a planned defended settlement (or *burh*) with a rectilinear street grid centred on Carfax.
Norman 1066–1204	• In 1071 a motte and bailey castle is built over the western end of the town. • The 1086 Domesday Survey records large areas of the town as waste ground. Subsequent growth leads to the division of existing tenements, the creation of new streets and the construction of new churches, priories, hospitals, the Grandpont causeway and Oseney Abbey. • By 1132 The Kings Houses, a minor Royal residence later known as the Royal Beaumont Palace, has been built north of the town. • The University emerges in the late twelfth century.
Later Medieval 1205–1540	• In the thirteenth century Cistercian monks and most of the mendicant friar orders are attracted to Oxford; some establish precincts outside the walled town on land reclaimed from the floodplain. • The town wall is rebuilt in the thirteenth century with bastions and unusual double (concentric) line along the north-east part of the circuit. • Oxford's economy falters in the late thirteenth and fourteenth centuries with increasing areas of the town recorded as waste. The same period sees the growth of academic halls and colleges associated with the University.
Post-medieval 1540–1800	• The Dissolution of the friaries and abbeys leaves the west and south-western suburbs of Oxford economically disadvantaged. • Oxford becomes a city with a cathedral established first at the former Oseney Abbey church then at Christ Church. • During the Civil War Charles I establishes his headquarters at Oxford and defensive and siege earthworks are built around the town leading to the clearance of part of the suburb St Clement's. In 1644 a major fire destroys many properties between George Street and Queen Street. • The late seventeenth century sees the expansion and rebuilding of the town, with land inside the town wall and the in-filled town ditch newly developed. • A major clearance of obstructions was undertaken by the 1771 Paving Commission including the demolition of remaining gates. New drains were laid and an indoor market replaced the historic street market. • The canal reaches Oxford in 1790.

A selective history of the prehistoric and historic settlement and development trends in the locality.

Introduction

Oxford has a rich legacy of below ground archaeological remains that matches its reputation as a city of fine buildings and views. It is this subterranean world that is the focus of this book rather than the buildings above. This is not because the visible townscape has nothing to teach us about the archaeology of the city: the central crossroads at Carfax points to the importance of this intersection of long-distance routes for exchange and trade – it signposts that Oxford has a different story to tell than other English towns laid out by Roman military surveyors or that have grown organically in a river bend or around a Norman castle; the subtle curves of some of the ancient streets capture the formation of early trackways around long-forgotten prehistoric earthworks; and the tenement plots established in the Late Saxon and Norman periods can still be seen in the surviving property boundaries.

The buildings of Oxford themselves, from the 1,000-year-old stone towers of St George at the castle and St Michael at the Northgate, through to the architects Herzog & de Meuron's multi-tiered off-centred wedding cake that is the Blavatnik School of Government, provide a three-dimensional textbook for students of English architecture and its continental influences. This above ground archaeology, as the Oxford-based building recording pioneer William Pantin described it in 1958, is well served with guides and textbooks. The below ground remains of the town on the other hand are perhaps less well known, despite the excellent publication record of local archaeologists in academic journals and monographs and the periodic coverage of digs by the local press. Indeed, the Oxford-based author Philip Pullman may have reached a wider audience with his fictional archaeology of the city provided as context for his short story *Lyra's Oxford* than the specialist literature. Here Pullman tells of Randolph Lucy's 1668 alchemical factory and of the Roman canal boat at Isis Lock. My challenge is to convince you that Oxford has produced and continues to produce real discoveries of equal interest and wonder.

The influences that have shaped Oxford's distinctive archaeological record are complex but can be briefly summarised. The site of the town is located within the natural communication corridor formed by the River Thames and its Pleistocene gravel terraces. The river and well drained gravels first attracted wandering Mesolithic hunter gatherers and then Neolithic and Early Bronze Age herders. The gravel promontory on which Oxford was later founded, formed by the junction of the Thames and its tributary, the River Cherwell, provided access to fording points across the braided channels of the floodplains below. It was chosen as a location for monumental and enigmatic Middle Neolithic to Early Bronze

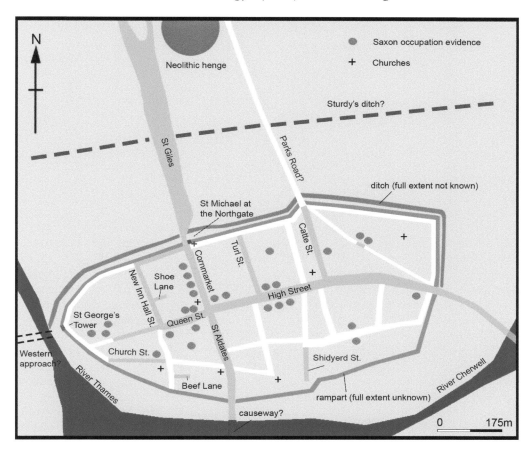

Plan showing Oxford in the early eleventh century. Known Late Saxon roads are shown in orange, conjected routes in white. (Modified after D. Poore et al., 2009, 'Excavations at Oxford Castle', *Oxoniensia* 74: 8, Figure 4)

Age earthworks that are believed to have fulfilled ritual, funerary and communal roles in the landscape. Subsequently, the Oxford gravel terrace was occupied by Iron Age and Roman agriculturalists and livestock farmers. The local Roman settlement was a modest village located in the vicinity of South Parks Road. Further to the east of Oxford an important pottery manufacturing industry grew up around the Dorchester to Alchester Roman road.

Once established in the Middle to Late Saxon period, a poorly understood early settlement, located in the vicinity of St Aldate's on the northern bank of the Thames, fortuitously proved to be located centrally within the landmass of southern–middle England on the route to other interesting and profitable locations along the four compass points: to the north Northampton and central Mercia; to the east London; to the south Winchester and the port at Hamwic (Southampton); and to the west Gloucester, on to Hereford, Brecon and St David's. The settlement was located at the boundary of two Middle Saxon Kingdoms, Wessex and Mercia, at a strategic crossing point on the island's largest river, leading to its growth and then its fortification against the Viking

threat. Through accident or fortuitous geography, the town became a convenient meeting place for Late Saxon, Danish and Norman kings and a successful early trading centre for cloth and other goods. Its economic success in the Norman period attracted several large religious institutions and it consequently proved a convenient location for the study of Roman and canon law.

The ensuing growth of the medieval university from the late twelfth century had two further profound impacts on the town's archaeological legacy. Firstly, the university attracted a diverse international community of lawyers, theologians and natural philosophers who needed to be fed, clothed and accommodated, along with rich patrons willing to pay for the construction of large monumental College precincts and university buildings. Secondly, the very act of constructing these buildings, with their associated quadrangles, gardens and kitchen yards, resulted in the substantial preservation of the remains of the earlier town below.

The short aim of this book is to provide an introduction to the archaeology of the city and promote a wider awareness of the pace and interest of ongoing discoveries. The content focuses mostly on the area of the walled town and its early suburbs from the prehistoric through to the medieval periods. The Historic Environment Record for Oxford catalogues 554 excavations of various sizes that have taken place to date. The format of this book has only allowed a summary of a handful of these sites and I have omitted numerous significant investigations. I would simply note that there is a more comprehensive account of the archaeology of the town waiting to be written, taking into account the growing body of data that has been recorded since archaeology was integrated into the planning system in England in 1990. I have chosen twenty excavation sites because such a number allows the reader to get a flavour of the broad range and character of the discoveries made over the last 150 years. Should the reader wish to find out more, a select bibliography is provided at the end of the book.

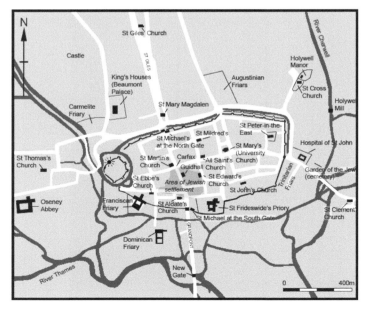

Plan showing Oxford in the thirteenth century, including the approximate area where the medieval Jewish community developed from *c.* 1075 through to the expulsion of the Jews from England in 1290. To date few archaeological remains have been excavated that can be confidently linked to the Jewish community but this may change as sites along St Aldate's are redeveloped. (Modified after G. Tyack, 1998, *Oxford: An Architectural Guide*, pp. 2–3, Map 2)

Dig 1

Prehistoric Pit Dwellings?

The University Examination Schools, formerly the Angel Inn, High Street, 1876

In 1876 a milestone was passed in the development of urban archaeology in Britain when Herbert Hurst, a topographer and leading member of the Oxford Architectural & Historical Society, undertook observations during the demolition of the Angel Inn, formerly an important coaching inn on the High Street. The building was demolished to make way for the University Examination Schools that now dominate the eastern end of the street. Hurst made notes of the discoveries and along with the architect T. G. Jackson oversaw the emptying of pits that had been revealed by the works. Some of the pottery recovered found its way to the Ashmolean Museum. Unfortunately many of the finds were not bought by local collectors and the site labourers took them to an antique shop on the High Street, from where they were scattered across the county.

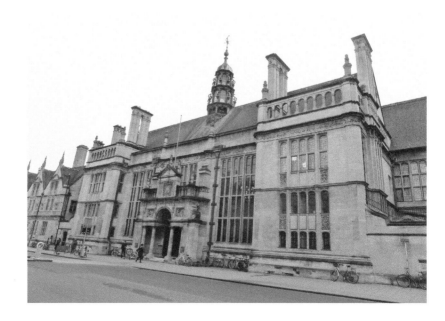

The Oxford University Examination Schools on the High Street, photographed in 2017 by the author.

Hurst's findings were reported in newspapers as far afield as Edinburgh, Jersey and London as the discovery of a 'British village' under Oxford and it was suggested that the curious moonscape of holes cut into the natural gravel indicated 'pit dwellings' belonging to Iron Age or Roman settlers. The evidence was hotly disputed at the time. Professor G. Rolleston, a fellow of Merton College whose interests included comparative anatomy, physiology and zoology, thought that as the pits seemed to fill with water when the nearby River Cherwell was high, they could not be dwellings, and must be simple gravel pits that had been filled with rubbish. Revd J. C. Clutterbuck, a keen local antiquarian, disagreed and said that they looked nothing like gravel pits, and in any case he believed that in Roman times the water level had been much lower because finds of this date had been recently recovered 5 feet down in the mud of the river.

A few years later General Augustus Pitt-Rivers was to apply more scientific methods when excavating an actual Iron Age settlement site at Lewes in Sussex. Here he investigated features within Mount Caburn hillfort that he adduced to be 'storage pits'. He published a 'relic table', which was a tabulated record of every feature excavated,

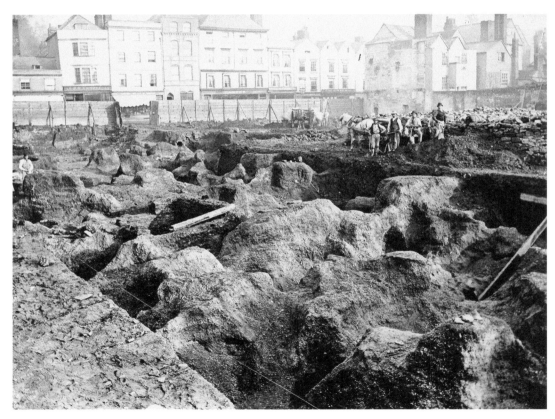

The archaeological excavation on the site of the Examination Schools, the site of the former Angel Inn, showing exposed pits and foundations. The Examination Schools building was completed by 1882 to a design by Thomas G. Jackson. (Henry W. Taunt, 1877, reproduced courtesy of the Oxfordshire County Council Photographic Archive, OCL 2157)

giving the date of excavation, artefacts recovered and dimensions – a breakthrough for archaeological recording techniques. His work gave additional weight to the idea that some of the Angel Inn features were perhaps later storage and rubbish pits rather than Iron Age 'pit dwellings'.

Following an archaeological excavation at the New Bodleian Library site in 1937 (see Dig 3) the Angel Inn finds in the Ashmolean Museum were re-assessed by Rupert Bruce-Mitford, best known for his work on the Anglo-Saxon ship burial at Sutton Hoo, and chemist-turned-archaeologist Martyn Jope. They identified the pottery from the Angel Inn site as Late Saxon and medieval rather than 'ancient British' and demonstrated that the excavation must have recovered the remains of urban frontage plots belonging to the eastern part of the Saxon and later medieval town. Jope's later excavations at the castle mound and Clarendon Hotel led him to identify the remains of a number of almost square cellar pits and also larger rectangular cellars, which are now known to be a distinctive feature of Oxford's urban expansion in the late tenth and eleventh centuries (see Dig 4). Jope thus came to the view that the Angel Inn site had preserved remains that were not Romano-British 'pit dwellings' but pits and cellars associated with simple Late Saxon wooden houses.

At both the castle mound and Angel Inn sites the remains of hard baked clay crucibles used for smelting bronze or perhaps other forms of metal working were recovered. Such crucibles continued to be used into the medieval period but at least one of the Angel Inn crucibles had been made using chopped grass as a temper to strengthen it after firing, making a Late Saxon date likely. Evidence for the smelting of metal, as opposed to the activities of blacksmiths who might use a simple forge to make tools, horse gear and domestic furniture, is rare within Late Saxon towns. In the 1895 report of the observations made at the Angel Inn site the remains of a furnace flue, charcoal waste and the possibility of gold smelting are also mentioned. Unfortunately, in the absence of detailed records from the excavation, we must rely on new discoveries to help us further understand the significance and extent of Late Saxon metal working in this part of the town.

As for the observation of waterlogging made by Professor Rolleston, this remains a difficult matter to resolve as we do not know to which features he was referring. It would have been curious if cellar pits had been constructed on land that was vulnerable to flooding. The available information from investigations along the upper River Thames suggests that developments in open field agriculture and the growing number of weirs and mills along the river in the Late Saxon period increased the area of land liable to flood. Furthermore, observations have shown that water rises up through the foundations of large College buildings located further east of the Examination Schools towards the River Cherwell when the river is high. It is therefore possible that this part of the Saxon settlement was marginal land. Why cellar pits might have been built in this area remains a mystery, one that only investigating similar nearby structures with modern archaeological techniques is likely to solve.

Dig 2

The Lost Saxon Wall

The Clarendon Quadrangle, Broad Street, 1899

Some guidebooks record that Oxford was founded as a burh or fortified settlement in the late ninth century by Alfred the Great, King of Wessex (849–899), as part of a reorganisation of the kingdom designed to resist Viking attacks. Being located on the north bank of the River Thames, Oxford fell within the historic territory of the Saxon kingdom of Mercia, but came under the control of Wessex in the late ninth century. Such was the attraction of the association with Alfred that from the late fourteenth century it was often claimed that the University itself could trace its origins back to his reign. Eventually more sober assessment of the evidence by the seventeenth-century historian Antony Wood located the emergence of the University to the late twelfth century.

As for the date that the burh was founded, this remains a matter of dispute. A poorly understood settlement developed near the river crossing in the vicinity of St Aldate's in the Middle Saxon period; whether this had defences of any substance remains unclear. Subsequently, a rectilinear town was laid out with defences comprising an earth and turf rampart, faced at first with a timber revetment and then a stone wall, with a wide outer ditch separated from the rampart by a strip of land or 'berm' (see also Dig 8). Archaeologists are still looking for confirmation that these defences were initiated by either Alfred, his son Edward the Elder (*c.* 870–924) or perhaps other lesser regional figures such as Mercian Ealdorman Æthelred (?–911) or his formidable wife, Alfred's daughter, Æthelflæd (*c.* 870–918). It is also possible that parts of the defended circuit originated earlier in the eighth century. Such an origin for at least part of the surviving buried Saxon rampart at New College has been suggested by recent scientific dates that are currently being prepared for publication.

The best evidence for the influence of Alfred are Viking copies of coins that bear his name and what appears to be corruption of the town's name spelt with a 'H' rather than an 'X' (*OHSNA/FORDA*). However, even if Alfred had established a mint at Oxford, it does not prove the existence of a defended burh at this time. The first documentary reference to Oxford is in the *Anglo-Saxon Chronicle* dated to 911–12 and the first reference to a burh at Oxford comes from a memorandum of the reign of Edward the Elder known as the *Burghal Hidage*. This lists thirty-three burhs, which were places of varying character that had been given fortifications in order to serve as defensive centres against the raiding Vikings. The document is currently believed to date to the period 914–19.

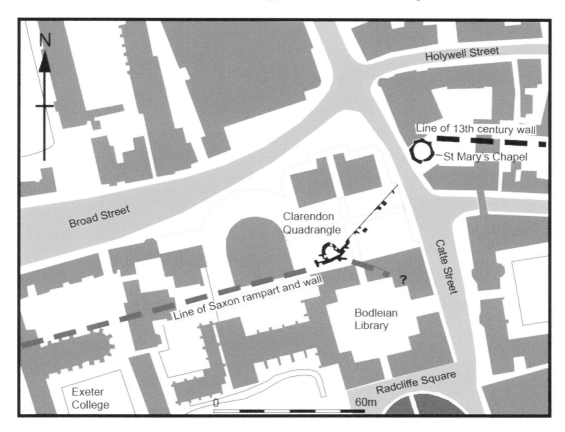

Above: Plan showing the location of the 1899 excavation in the Clarendon Quadrangle. The location of St Mary's Chapel is shown for orientation. The chapel was in existence by the late fourteenth century and likely formed part of the Smithgate. It was later rebuilt and eventually converted into the Hertford College Junior Common Room. (Modified after A. Dodd (ed.), 2003, p. 173, Figure 4.21).

Right: The Radcliffe Camera, viewed from the tower of St Mary's Church. To the right is Catte Street and to the left the line of Schools Street. The proximity of these two medieval streets and their similarity to a similar street layout found at the burh in Hereford is one possible clue to the presence of a double or extended burh at Oxford. Photographed in 2017 by the author.

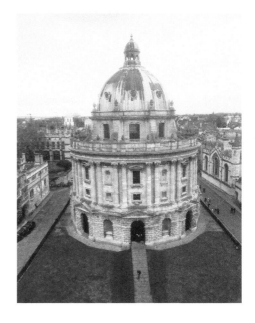

A hide was an English unit of land measurement originally intended to represent the amount of land sufficient to support a household, but became linked to the calculation of taxes needed to pay for other obligations such as the creation and maintenance of fortifications. According to a mathematical calculation provided in the text of the *Burghal Hidage*, 20 metres of burh defence can be defended by sixteen men. In theory, this should allow the size of the defences for each town to be calculated by the number of hides recorded. Unfortunately, the Oxford reference in surviving texts is corrupted and significantly different readings are possible. Historians and archaeologists have looked at the evidence and the shape of the surviving street grid and argued for a variety of defensive scenarios, including the foundation of a smaller, squarer, primary burh that was then expanded east and west, or alternatively that a larger more irregular primary burh was expanded eastwards.

A crucial piece of archaeological evidence in this debate was recorded during another pathfinding excavation in the Clarendon Quadrangle in 1899 by the Excavation Committee of the Oxford Architectural & Historical Society, under the auspices of its president and future Bodleian Librarian Falconer Madan (1851–1935) and Herbert Hurst.

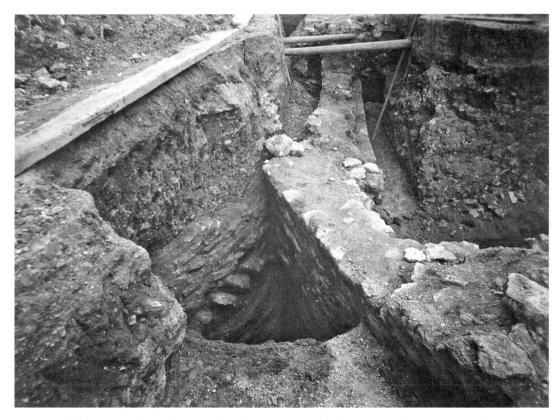

A view of the 1899 Clarendon Quadrangle excavation looking west, showing an early wall turning south (left) from the thirteenth-century town wall. (Henry W. Taunt, 1899, reproduced courtesy of the Oxfordshire Architectural & Historical Society)

The project may be considered the first modern excavation undertaken in Oxford as it resulted in archived plans and photographs that are still kept in the Society's collection and a finds archive that was deposited in the Ashmolean Museum. The excavation uncovered part of the town wall and a bastion dating from when the bulk of the town wall was substantially rebuilt in the first half of the thirteenth century. At this time records survive of murage grants (rights to exact tolls for the building or repair of town walls) and gifts of materials from the Crown. These records are dated between 1226 and 1240 and provide the best evidence for a concerted phase of rebuilding of the earlier town wall, which was likely to have been built in the Late Saxon period and must have been periodically repaired. No detailed survey of the surviving town wall has ever been undertaken and the extent to which there may be stretches of pre-thirteenth-century fabric surviving remains poorly understood.

At the Clarendon Quadrangle the thirteenth-century wall running eastwards from the castle precinct suddenly changes direction and kinks north-eastwards towards the former Smithgate, near Hertford College. This change in alignment was already clear from the above ground remains of the walled circuit but what was also recorded, planned and photographed in 1899 was an earlier, simpler wall, heading south-eastwards on a slight curve at the point that the thirteenth-century line changed direction. This wall was faced with limestone blocks and packed with red loam to bond the rubble core of coral rag together. The site records, re-examined by Julian Munby, suggest that the wall was built up against an earthwork bank, presumed to be the Late Saxon rampart. Thus, the investigations appeared to have recovered the remains of the early eastern wall of a smaller primary burh.

Often neat solutions can be elusive in archaeology and a new discovery simply creates new, more vexing questions. Significant problems remain in terms of interpreting the Clarendon Quadrangle wall. Crucially, if the wall headed southwards on the slight curve recorded by Hurst, why was it not seen in the large basement excavated just to the south for the Bodleian Library book stacks in Radcliffe Square in 1909?

These works were observed by pottery enthusiast and Ashmolean volunteer T. E. Lawrence (1888–1935), who later obtained the moniker Lawrence of Arabia. As a schoolboy, Lawrence had developed a passion for scavenging around local building sites for pottery and then attempting to reconstruct the pots using plasticine. At this time the Ashmolean would offer small sums of money for choice items. In 1909 Lawrence returned from a walking tour of Crusader fortifications in Syria to finish his summer vacation observing the Radcliffe Square excavation. The notes he and others made about the site recorded the foundations, cellars, waste pits and wells belonging to medieval and post-medieval tenements located along Schools Street before these had been cleared in the eighteenth century for the construction of the Radcliffe Camera. Yet no trace of a large Saxon wall, rampart or outer ditch was noted by Lawrence or other observers. The date, projected line and significance of the Clarendon Quadrangle 'Saxon' wall therefore remain a matter of debate.

Dig 3

Rescuing Pots from the Grab-Jaw

The New Bodleian, 35–47 Broad Street, 1937

In 1935 Oxford University took the decision to demolish a group of seventeenth-century houses on the north side of Broad Street, at the corner with Parks Road, in order to build a large extension to the Bodleian Library. The houses formed part of the northern suburb that had developed along Broad Street, formerly Horse Monger Street, in the medieval period. With great foresight, the Bodleian Librarian, Sir Edmund Craster (1879–1959), invited the Oxford Archaeological & Architectural Society to record the buildings before demolition and to observe the finds recovered from the 7-metre-deep hole made for the basement of the new library building.

 The job of watching the basement excavation in 1937 was given to Rupert Bruce-Mitford (1914–94), an Oxford graduate who had just acquired a one-year temporary appointment as Assistant Keeper at the Ashmolean Museum. The task was

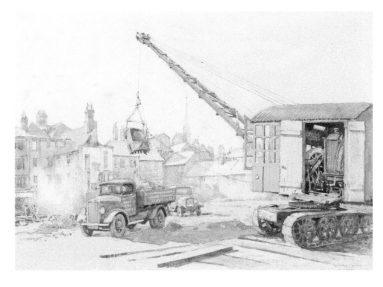

Watercolour of lorries and a mechanical digger during the demolition of Nos 35–47 Broad Street in 1937 by B. C. Gotch (1876–1964). (Reproduced with the permission of the Ashmolean Museum, © Artist's Estate)

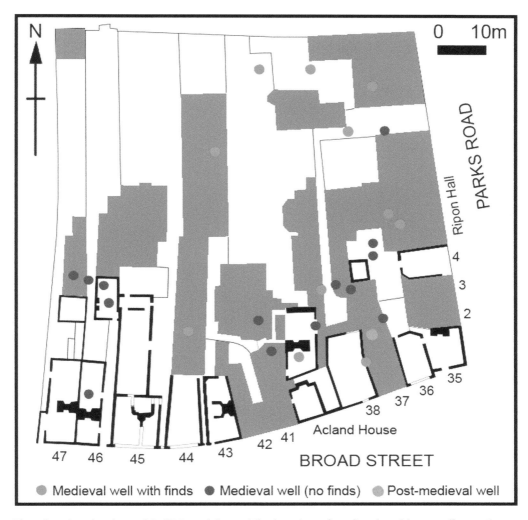

Plan showing the site at 35–47 Broad Street. The location of medieval and later wells are shown along with structures of mid-eighteenth century or earlier date (in black). (Modified after R. L. S. Bruce-Mitford, 1939, 'The Archaeology of the Site of the Bodleian Extension in Broad Street, Oxford', *Oxoniensia* 4: 90, Figure 20)

not a straightforward matter as the developer had no intention of stopping work in order to allow archaeologists to poke around the remains. Below the seventeenth-century buildings, which were recorded before demolition by pioneering building specialist William Pantin, were the remains of medieval houses. These had occupied narrow strips of land leading back from frontages on Broad Street and each had at least one well dug down through the terrace gravel to the London Clay below. Over twenty-four wells were recorded across the 65 by 70 metre site. In the bottom metre of mud at the bottom of each well was a treasure trove of medieval and post-medieval pottery. However, getting to these finds was a challenge as the 'grab-jaw' of the mechanical digger would

Rupert L. S. Bruce-Mitford (1914–1994). (Copyright © National Portrait Gallery; reproduced by permission)

simply scoop up the bottom of the stone-lined well and dump it into a waiting tipper lorry. Bruce-Mitford's job was to jump onto the lorry and frantically sort through the mud to recover the buried finds before the lorry reached the tip in the village of Cumnor to the west of the town. If he was lucky he would get a ride back to Oxford on the empty lorry. Other times he had to catch the bus with his sack of finds.

The New Bodleian dig was thus one of England's first urban 'rescue excavations' and a major step forward for the study of medieval archaeology in Britain. Bruce-Mitford took the pottery sherds back to the Ashmolean Museum, where he attempted to reconstruct the vessels, drew them and eventually published his findings. The pottery from the various pits and wells was assembled into a sequence of ceramic groups in their probable chronological order. The result was the first serious modern study of English medieval pottery and eventually the creation of a national reference database at the British Museum. Bruce-Mitford produced a chronological sequence of pottery for Oxford that has never been overturned, although it has been refined and extended.

Dig 4

Homes Fit for a Thegn

The Clarendon Hotel, Cornmarket, 1954–7

During the Second World War, central Oxford escaped bombing by the Luftwaffe; therefore, unlike many other English towns, there was not a pressing need to repair and replace war damage after 1945. But despite Oxford's good fortune the pre-war growth of the Cowley Car Plant and consequently the expansion of the town's population put pressure on the city council to discuss various plans for renewal and expansion in the 1950s.

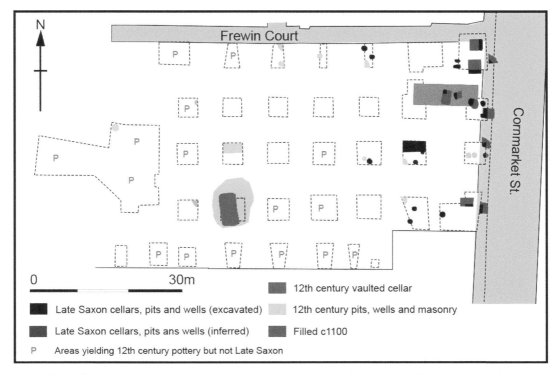

N

Frewin Court

Cornmarket St.

0 30m

■ Late Saxon cellars, pits and wells (excavated)	■ 12th century vaulted cellar
■ Late Saxon cellars, pits ans wells (inferred)	□ 12th century pits, wells and masonry
P Areas yielding 12th century pottery but not Late Saxon	■ Filled c1100

Plan of the Clarendon Hotel site, Cornmarket Street, showing the foundation grid and the projected extent of the Late Saxon archaeology. (Modified after E. M. Jope, 1958, 'The Clarendon Hotel, Oxford, Part 1: The Site', *Oxoniensia* 23: 4, Figure 1)

One of the first projects to be agreed was the demolition and redevelopment of the Clarendon Hotel on Cornmarket Street in 1954–7. The hotel was to be replaced by a new Woolworth's store, now the site of the Clarendon Shopping Centre.

The ensuing demolition work enabled William Pantin to produce a record of the medieval and later inns on the site, including the hotel's wine cellar – a fine twelfth-century vaulted structure. From this work he was able to suggest the form of the original twelfth-century tenements along this part of Cornmarket Street. The excavation that followed was arguably the single most important investigation of Late Saxon remains undertaken in the town to date. A team of archaeologists, funded by the Ministry of Works and led by Martyn Jope, was able to examine an extensive plot of land in the heart of the burh.

As with previous sites, the archaeologists had to work around the logistical requirements of the developer. In this instance the new building was to be constructed on a grid of 4.5-metre-square stanchion holes. These rectangular windows into the Saxon town were occasionally investigated by hand and at other times simply observed, sometimes in the fading light of dusk. Larger features suspected of continuing beyond the foundation trenches were prodded with augers to get an approximation of their shape. Despite taking place under less than ideal conditions, the recording project was able to recover considerable information about the character of Late Saxon settlement on this axial north–south route, one of the four streets leading off the central crossroads at Carfax that were the venue for the weekly medieval street market.

The earliest levels of the Clarendon dig recovered the day-to-day detritus of Late Saxon urban life: the bones of pigs, sheep, oxen, geese, cats and dogs; the remains of cooking pots, iron buckles and knifes; and traces of weaving activity in the form of loom weights, bone combs, spindle whorls and bone thread pickers. The latter provided evidence for the use of vertical looms that were commonly used by local weavers until they were replaced by the horizontal loom in the thirteenth century. Other finds pointed to industrial working behind the street frontage; for example, fragments of small crucibles caked in red-tinged slag that may have been used for bronze working and a mould of oolitic limestone used for casting silver ingots.

Perhaps of greater interest than these myriad small finds was the recovery of the basic layout of the Saxon street frontage. The excavation recorded a series of steep-sided cellars, rubbish pits and wells that indicated how the early settlement plots had been arranged. Few boundaries were identified and it seems that the early plots were large and occupied by irregular arrangements of buildings in contrast with the denser narrower strips and the more regimented street frontages that developed during the Norman period. Jope established that the original Late Saxon street frontage extended some 3 metres into the current Cornmarket Street. The frontage was crowded with features, including small 2.5-metre-square cellar pits lined with clay or wattle that may have been used for the cool storage of food stuffs, perhaps for use by shops, market stalls or street traders. To the rear the pattern was far less congested with larger 6 by 3 metre cellars cut into the natural gravel with a variety of orientations, set back from the frontage within the generous plots. These more substantial cellars would have had wooden floors and walls and some contained post holes to support house structures above. Similar structures have been found in contemporary Saxon towns, for example at nearby Wallingford. Here Brian Durham has suggested that they may have functioned as safe storage spaces in structures vulnerable to fire.

The Late Saxon plots appeared to have contained a mixture of domestic buildings and workshops with big open spaces behind. There was little evidence for the digging of extensive pits for rubbish, cess and gravel that are to be found to the rear of later medieval tenements. This pattern of early settlement was similar in character to that revealed at another Late Saxon burh – Winchester, the capital of Wessex – by archaeologist Martin Biddle in the 1960s. Here large plots within the town were occupied by a main house or hall, surrounded by the houses of dependents and sometimes even associated with a small church. Rather than being divided into narrow strips of tenements, the holdings could be made up of whole blocks defined by streets and lanes. Biddle suggests that these blocks may have initially belonged to ealdormen or thegns (i.e. high-ranking officials or aristocratic retainers of the king or noblemen), the elite of Saxon society, who also held estates in the country. Such urban manors may have originated as smaller copies of these country estates and would have provided their owners access to the emerging urban markets of the tenth century and a place of refuge in times of trouble.

Over time the pressure to divide up the frontage plots for trading opportunities and rents led to their subdivision. The accumulated archaeological evidence from investigations such as that undertaken at the Clarendon Hotel suggests that the underlying framework of the present-day tenement plots – at least in the central part of town – was probably first laid out in the late tenth to early eleventh century. By the twelfth century these blocks had been further divided into the tenement strips identified by William Pantin in his survey of Cornmarket Street. Archaeologists remain divided on how uniform this process was and how rapidly it took place. Ultimately the Clarendon Hotel dig was unable to fully reveal the subtle complexities of how the Late Saxon street frontage evolved from the ninth to eleventh century. Nevertheless, despite the less than favourable conditions, it represented a once-in-a-generation chance to gain an insight into this process of transformation in a key central location.

Dig 5

The Church with Two Naves

The Westgate Shopping Centre, St Ebbe's, 1967–76

A second major phase of post-war development began in 1964 when the city council decided to redevelop a substantial part of the parish of St Ebbe's and make space for the Westgate Shopping Centre, which was completed in 1976. The development site straddled medieval Church Street inside the town wall and land to the south of the wall encompassing much of the precinct of the medieval Greyfriars and the late Regency and Victorian suburb of St Ebbe's.

The suburb had been developed over mostly rough pasture land in the 1820s and its mixed quality brick terraces had been marketed as desirable suburban housing. Following outbreaks of cholera in the 1830s, the fortunes of the area deteriorated. Subsequently, the open Trill Mill stream was culverted and municipal waste was removed to new tips at the edge of the city. By the 1960s the Council had come to the view that the area should be cleared and many of the residents were moved to new estates to the east of the city.

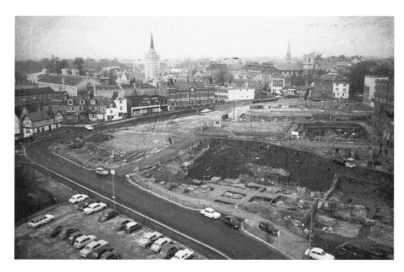

Aerial view of the Westgate development site in St Ebbe's looking north, taken in late 1968 to early 1969 by Tom Hassall from the top of Oxford City Fire Brigade's 120-foot escape turntable ladder. (Reproduced courtesy of Oxford Archaeology)

Such was the scale of the clearance project that it was decided that the previous arrangement of an ad hoc archaeological excavations committee was insufficient. The challenge was outlined in a 1966 report *City of Oxford, Archaeological Implications* by Jean Cook and Don Benson, the first in what became a national genre of archaeological surveys looking at the implications of new development. Following the recommendations of the report, a new team of full-time archaeologists was established in 1967 under the control of the Oxford Archaeological Excavation Committee. In 1973 this was replaced by a new independent educational charity, the Oxfordshire Archaeological Unit, now known as Oxford Archaeology.

The Westgate dig, directed by Tom Hassall, was the largest excavation that had been undertaken in the city up to that point. The archaeologists were given access to much of the extensive development site but had to target their work given the limited resources and funds available. It was decided to focus on the church of the Franciscan friary and specific plots on Littlegate Street and Church Street in the hope that this would provide a coherent sequence of remains and an insight into the pattern of Saxon through to modern development. Other areas were subject to sample trenching or were observed during ground reduction works.

Oxford's Franciscan friary was founded in the 1220s by a small party of Franciscans that had landed in Kent with St Agnelus of Pisa, founder of the provincial order. When he died Agnelus was buried at the Oxford friary, although his remains, recorded as being placed in a lead coffin, have never been discovered. Soon the Franciscans began accumulating land within the town walls by bequest with a view to establishing their own precinct south of Church Street. The early houses were 'mean and small' and the friars developed a reputation for enthusiasm, self-sacrifice and piety. Yet, despite the belief of St Francis that the order should not involve itself with higher education, the Oxford friars rapidly became closely associated with the emerging University. The formidable natural philosopher Robert Grosseteste, the first recorded Chancellor of Oxford University, although not a Franciscan himself became the first lector, or teacher, to the friars. Under his guidance the friary became a centre of learning for the order

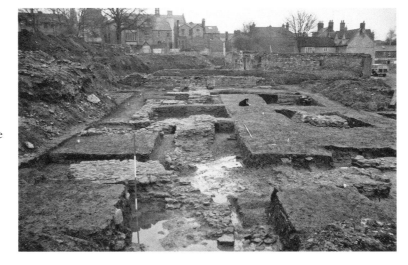

View of the Westgate excavation looking east along the robbed wall of the north aisle of the Greyfriars Church. (Reproduced courtesy of Oxford Archaeology)

and by the late thirteenth century it can be described as a *studium generale* – a place of higher education that attracted students from far afield – and was comparable in status only to the Franciscan convents at Cambridge and Paris. The friary attracted students from across Europe, including France, Aquitaine, Italy, Spain, Portugal and Germany. Grosseteste is said to have cautioned the friars against excessive austerity, arguing that good temporal health required them to eat, sleep and be merry. His work and that of succeeding generations of Franciscan scholars at Oxford, including Roger Bacon, Duns Scotus and William of Ockham, represents a high watermark for early scientific and theological thinking in England in the thirteenth and early fourteenth century.

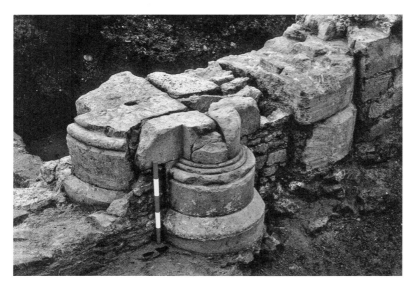

The excavated pier bases from the junction of the north nave and the main nave of the Greyfriars church. These pier bases are now preserved in a concrete cellar within the current Sainsbury's store at the Westgate Shopping Centre. (Reproduced courtesy of Oxford Archaeology)

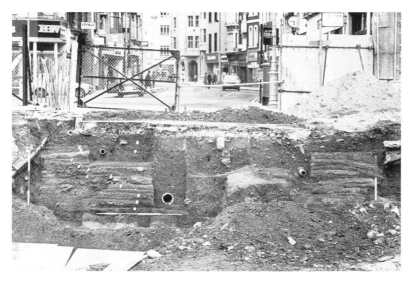

Section across Castle Street, looking towards Carfax, showing the accumulation of Late Saxon and later road surfaces cut by later service trenches. (Reproduced courtesy of Oxford Archaeology)

The Westgate excavation led to a number of important discoveries, notably the distinctive plan of the large friary church. The friary had been dissolved and demolished in the 1530s. The stripping and recycling of the site was so complete that by the time it was drawn by Ralph Agas in 1578 for his town map only a single building was shown as surviving. The archaeologists therefore started with only fragmentary documentary records to guide them. In 1232 Henry III had donated wood from Savernake Forest to build a chapel in the first Franciscan precinct, which was located south of Church Street and north of the town wall. By 1245 a new church was underway, this time built across the line of the town wall after the King had allowed the extension of the Greyfriars precinct southwards. In 1346 Wheatley stone was gifted to repair the church by Edward III and the finished church was later described in its completed form by William Worcestre after a visit in 1480. He described a 'north nave' that was forty paces across and contained ten chapels.

The excavation resolved the curious dimensions provided by Worcestre by showing that in addition to the standard chancel and eastern choir, the church had an unusual arrangement of two naves – one orientated east–west and the other north–south – off a crossing below a central tower. Tom Hassall suggests that the design, with the large second nave to the north containing multiple side chapels, may be explained by the teaching function of the friary. Such a 'teaching nave' allowed a lector standing centrally to communicate with a large number of students.

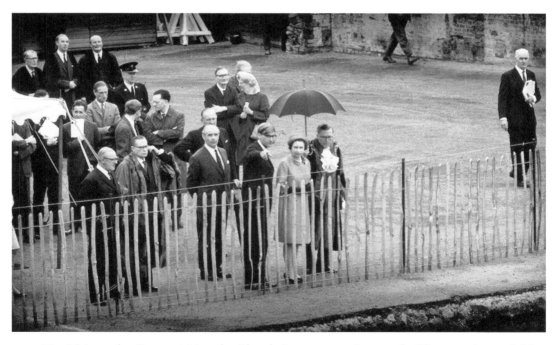

Her Majesty the Queen visiting the Church Street excavations at the Westgate site on 2 May 1968. Centre: HM the Queen; left: Tom Hassall, Director of Excavations, Oxford Archaeological Excavation Committee; Douglas Murray, Oxford City Architect; right: The Lord Mayor, Frank Pickstock. (Reproduced courtesy of Oxford Archaeology)

Other finds included fifty-eight burials from inside and outside the church, including one skeleton that was found with an iron fetter around one leg. The burials were mostly male with only a few possible female skeletons and therefore are likely to be the remains of friars and their patrons who are known to have included some wealthy women including for example Beatrice van Valkenburg, wife of the Earl of Cornwall, who was buried here in 1277. To the south of the church the stone-lined conduit that provided the friary with the luxury of running water was partly exposed, as were traces of the other friary buildings arranged around the main cloister. Only minimal trenching was possible in this area, leaving the function of these structures largely a mystery. They were subsequently entombed below a large multi-storey car park.

To the north of the friary the dig examined settlement plots belonging to the Saxon and medieval town in Church Street. A particularly significant find was a large north–south ditch that was sealed by the earliest Saxon street metaling and may yet prove to be an important clue about the character of the settlement that preceded the creation of the Saxon burh. Unfortunately, the sheer density of later inter-cut rubbish pits made it hard to establish the character and extent of activity predating the Norman Conquest. Instead the finds demonstrated the vibrancy of medieval commerce and industry in the western part of the town; for example, sherds of wine jugs from Saintonge in southern France were recovered from the tenement occupied by the wine trader John of Coleshill in the later thirteenth century.

As well as blocks of medieval and post-medieval tenements, the thirteenth-century town wall and site of the medieval Littlegate were also examined. These investigations failed to identify any trace of an earlier Saxon wall underneath or near to the thirteenth-century town wall to the east of the friary, therefore leaving a question mark over the line of the southern Saxon defences. Elsewhere, on Castle Street the large construction cut for the new shopping arcade revealed a striking vertical section showing how the surfaces of the street had been built up and repaired since the first Saxon street metalling. This was 2.3 metres deep with at least eighteen different surfaces identified and has become a textbook example of urban street development. For the first time in the town, the excavators also recovered and studied large waste assemblages of pottery, clay pipe and glassware from late post-medieval and early modern stone-lined waste pits, demonstrating how ideas of what constitutes 'archaeology' are constantly shifting.

The results of the dig were comprehensively published in the journal *Oxoniensia*. Ultimately the excavation became a significant source of civic pride and led to the formation of a City Museum in the Town Hall. The excavations generated considerable interest and were visited by Queen Elizabeth II in 1968 and also by the Father General of the Franciscan Order. Tom Hassall remembers that when Prince Philip visited the completed centre with the Queen in 1976, he wondered aloud how long it would be before the new buildings were pulled down and a new excavation commenced. The answer to this rhetorical question turned out to be approximately forty years (see Dig 19).

Dig 6

Bread, Metal and God

All Saints Church, High Street, 1973–4

Opportunities to excavate urban medieval church sites are few and far between and the several churches in Oxford that are likely to have Saxon origins have at best been subject to small-scale and piecemeal investigations. A notable exception is All Saints Church on the High Street, which, between 1973 and 1974, was excavated prior to its conversion into a library for Lincoln College and shown to be of likely post-Conquest date. The conversion of this splendid Baroque church, built between 1701 and 1710 after the tower of the old medieval church collapsed, required the insertion of an underground reading room. With the support of Lincoln College, a salvage excavation was arranged, directed by Brian Durham on behalf of the Oxford Archaeological Excavation Committee.

The site produced a particularly clear sequence of archaeological layers (in archaeological language, it was 'well stratified') and one of the best Late Saxon pottery assemblages as yet recovered from the town, deepening our understanding of the

All Saint's Church, High Street, photographed in 2017 by the author.

trade and consumption patterns of this period. From the ninth century to the Norman invasion, local potters seem to have favoured using locally sourced shelly Jurassic clay and crafted hand-made pots that were local staples. However, after the establishment of an area of Viking control across East Anglia and parts of the Midlands from the late ninth century, known as 'the Danelaw', potters were attracted to fortified trading centres at Thetford and Stamford and began to supply trading networks that stretched from the Danelaw well into Saxon territory, including down to Oxford. The Late Saxon pottery from the All Saints site included imports from Northern France and the Rhineland, demonstrating the town's developing trade links. It also produced quantities of early Stamford ware (*c.* 850–1100) and significant quantities of fine wheel-thrown pottery known as St Neot's ware (*c.* 875–1100), supplied by the trading network of the Danelaw. The latter ware became noticeably popular in Oxford during the early to middle eleventh century.

The pottery specialist for the All Saint's excavation, Maureen Mellor, went on to develop a detailed pottery 'type series' for Oxfordshire; i.e. a best guess for the sequence and date of different pottery types and industries, building on the pioneering work of Bruce-Mitford and Martyn Jope. A series of well-stratified excavations undertaken in the 1970s at 79–80 St Aldate's, The Hamel and All Saint's Church proved invaluable to this process. Mellor has suggested that the varied distribution of St Neot's Ware and other more local pottery traditions across Oxford might represent the cultural preferences of migrants from the Danelaw, who favoured it over local hand-made shelly ware products, and the Mercian population, who remained loyal to the local potteries. A further dimension to this theory is the possibility that incoming migrants may have initially moved to more inexpensive plots on the fringes of the town and over time occupied more central locations. The theory continues to be tested as new sites are excavated.

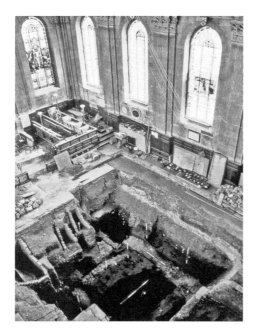

The excavation within All Saint's Church as it reached the lowest Late Saxon levels, looking north-west. (Reproduced courtesy of Brian Durham)

The All Saints dig was able to reveal a complex sequence of Saxon domestic occupation followed by at least six phases relating the development of the early church, dating from the second half of the eleventh century through to the fifteenth century. The earliest evidence for activity on the site could only be broadly dated to the ninth or tenth century and included the charred remains of a large quantity of threshed and cleaned wheat grain. Further charred grain has been found in subsequent nearby excavations and it appears that this area east of Turl Street may have served as a secure granary in the early years of the settlement, with large quantities of free threshing wheat and barley kept for baking or malting.

In the later tenth century more substantial buildings were established at the site, and in the early to mid-eleventh century a large wooden-lined cellar was constructed. Its backfill contained cess, domestic waste and a coin of Edward the Confessor minted between 1042 and 1044, providing a date on or after which the backfilling must have happened. This date fits well with other evidence from the town that points to a significant increase in building activity in the immediate pre- and post-Conquest period (*c.* 1040–70), with the laying out of tenement plots and the spread of these distinctive urban cellar pit forms as commerce flourished.

In the second half of the eleventh century a small single-celled stone building with mortared walls was built. Soon after a small room was added to the north and the cell extended eastwards. It is possible that these simple rooms represent an early church. However, this initial interpretation appeared to be confounded by the addition of furnaces to the original cell in the twelfth century. Lead and copper waste was recovered nearby, leading the excavator to consider whether the buildings might instead have had some kind of industrial use. Further work by Dr Peter Northover analysed the waste metal from the furnaces and showed it to be high tin bronze. Such metal is used for, among other things, making medieval church bells and Northover's work suggests that the furnaces and waste may therefore be the remnants of the on-site casting of church bells.

All Saints is first documented when it was granted to the nearby Augustinian Priory of St Frideswide's in 1122. Over time it became a wealthy church associated with guilds of glovers, skinners and goldsmiths, its parishioners drawn from the wealthy traders who occupied the High Street frontages. The 1973–4 excavation investigated parts of the twelfth to fourteenth-century church cemetery and as with many parish cemeteries the burials were heavily intercut, representing multiple generations. As a result, the skeletal remains were generally incomplete. Nevertheless, the remains of up to sixteen individuals were recovered from the likely twelfth-century cemetery and a further thirty-two from the interior of the later medieval church. The skeletons showed a consistent pattern of poor dental hygiene, bowed limbs and bent backs. The sample is too small and fragmentary to provide a detailed guide to local lifestyles but we might imagine the wear on the bones resulting from the practice of manual trades, the wear on the teeth as the result of grit contained in the stone-ground flour used for making medieval bread and the incidences of dental carries perhaps reflecting the greater access to processed sugar enjoyed by more affluent town dwellers.

Dig 7

Building Homes on the Floodplain

Port Meadow, 1981–5

For the next excavation we take a trip north along the River Thames. Located on the east bank of the river 1.6 km north of the walled town, Port Meadow is one of Oxford's greatest archaeological assets. Although called a meadow, the 120-hectare site is only known to have been used for hay crops during the Civil War and otherwise appears to have been in use as an area of common grazing land dating back to Late Saxon times or even earlier. The Domesday Survey records that that 'the burgesses of Oxford have pasture outside the walls in common' and in 1185 this is named as the portmanneyt or 'meadow of the portmen'. At this time towns were sometimes referred to as 'ports', describing their role as local markets. The roads leading to these markets, such as the Banbury Road, were port-ways, senior officials were portreeves and burgesses were portmen.

One of the Middle Iron Age enclosures on Port Meadow. The buried ditches show up greener as they retain more moisture and the entrance is dryer and lighter. The archaeologist George Lambrick is pictured on the left. (Reproduced courtesy of Oxford City Council)

The continued use of Port Meadow for grazing has produced a very special ecosystem where rare plants, notably creeping marshwort (*Apium repens*), flourish and it is consequently a Site of Special Scientific Interest. Another feature of the meadow is that the absence of intensive agriculture has preserved a range of upstanding prehistoric and later monuments. These include at least six and perhaps more Late Neolithic to Early Bronze Age barrows of 'disc' and 'bowl' type broadly datable to the period *c.* 2500 to 1500 BC. The only one of these barrows that is easily identifiable is the so-called Round Hill, which was subjected to one of the earliest recorded archaeological excavations in the country in 1842 by the then Sherriff of Oxford, James Hunt, and is now much disturbed and re-profiled, the current mound being largely the spoil heap of the dig. Among other miscellaneous remains, Port Meadow also contains traces of Iron Age settlements; illegal late/post-medieval quarrying; Civil War earthworks; post-medieval and Victorian race courses; and a historic airfield that was established before the First World War, used for Royal Flying Corps training and, in the interwar years, local air shows.

The Middle Iron Age (*c.* 350 to 50 BC) remains include rare upstanding earthworks, though very slight, of farmsteads with round houses surrounded by penannular ditches, small paddocks and fields. These were located on areas of slightly higher, drier

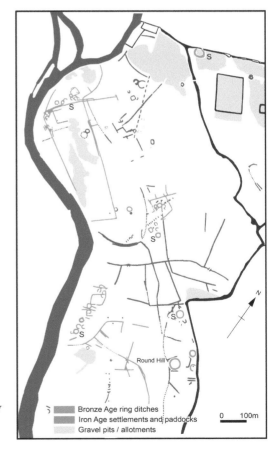

Plan of the parch marks at Port Meadow showing the locations of the 1980s investigations (labelled 'S' for samples). (Modified after G. Lambrick et al., 2009, *Thames Through Time: The Archaeology of the Gravel Terraces of the Upper and Middle Thames: The Thames Valley in Late Prehistory: 1500 BC – AD 50*. Thames Valley Landscapes Monograph 29, Oxford: Oxford Archaeology, Figure 3.21)

gravel between damp relict river channels. Some house sites survive as slight rises or depressions in the ground with doorways facing east, away from the prevailing winds. In dry summers, when the grass on the thin gravel soil is parched, the vegetation over moisture-retentive ditches and drip gullies of the enclosures and huts shows up green and taller. Two of the house enclosures within the northernmost farmstead have slightly sunken interiors, which archaeologist George Lambrick suggests is where the herders stripped the original turf to create dry gravel floor surfaces, and in the process provided material for the walls of the houses.

Port Meadow has not been subject to extensive archaeological investigation; however, a few small excavations have taken place, including sampling work funded by the British Academy undertaken between 1981 and 1985 by the Oxford Archaeological Unit and published by George Lambrick and Mark Robinson. By examining Port Meadow and other sites they sought to explain the development of the Thames floodplain over time: how and when grassland replaced tree cover; why prehistoric peoples built monuments and farmsteads on land that today is regularly underwater; how and why the incidence of flooding and alluvial deposition changed through time; and the importance and changing role of grassland exploitation in prehistoric and later societies. To this end small slots were excavated across the ditches of two of the Late Neolithic to Early Bronze Age barrows and ditches belonging to the three Iron Age homesteads in order to recover environmental samples and examine the character of the buried silts and soil.

The trenches across the Late Neolithic to Early Bronze Age barrow ditches showed that they had been created in dry conditions as organic remains like seeds, pollen and insects had not been preserved, and evidence for 'gleying' – a distinctive grey soil colour that develops when a ditch has been saturated with groundwater – had not occurred. In contrast, the Iron Age ditches had preserved organic peaty deposits and evidence of gleying, indicating more or less continuous waterlogging. These small surgical excavations thus provided evidence of a rise in the permanent water table between *c.* 1500 and *c.* 350 BC, reflecting clearance of woodland upstream on the slopes of the Cotswolds as population expanded in the Late Bronze Age and Early Iron Age. Thus, the barrows had been built in such low-lying locations because in the Early Bronze Age Port Meadow had been much less prone to flooding.

The lack of preserved organic remains means that there is little evidence of how the land surrounding the barrows was used, though even by then it may have been open pasture. This was certainly the case by the Middle Iron Age with the preserved insects and seeds from the farmsteads indicating open, heavily grazed, dung-enriched damp grassland. The perennial weeds from the ditches indicate that, unlike similar examples at Farmoor, the settlements were relatively permanent; they may or may not have been occupied year-round, but do seem to reflect a focus on the management of grazing which would have complemented mixed farming on the drier gravel terraces that were more suited to crop growing.

Apart from the presence of mucky farmyard habitats, the Iron Age vegetation of Port Meadow was very much as it is today. This raises the remarkable possibility that the common rights under which herds of cattle graze the meadow today reflect a surviving practice that not only stretches back to before the Domesday Survey, but all the way back to the first millennium BC, or even earlier – a bit of living prehistory.

Dig 8

The Saxon Rampart

No. 24a St Michael's Street, 1985

Here we return to the subject of Oxford's Late Saxon urban defences. In the eighth and ninth centuries the conflicts between the kingdoms of Mercia and Wessex and the subsequent arrival of the Vikings forced changes in the geography of Saxon settlement and led to the creation of new defended central places to complement the strongholds that had developed in reoccupied Roman walled towns. These defended spaces, protected by earth ramparts and outer ditches, were sometimes simply places of refuge in times of trouble; others had trading functions and began to develop the character of towns. Dating the emergence of this trend has proved challenging for archaeologists as they appear at a time when the pottery produced was crude and hard to divide into a tight chronological sequence. Nevertheless, at present there is some evidence that the construction of these defended settlements may have begun in the Middle Saxon kingdom of Mercia in the eighth century, with archaeologist Steve Bassett suggesting Hereford, Tamworth, Winchcombe and Worcester as likely examples of early Mercian burhs.

St Michael's Street looking west; Mallams Showroom is the brick building second from right. Photograph taken in 2017 by the author.

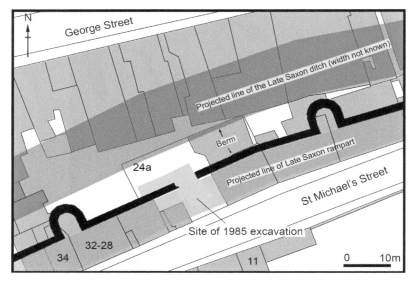

Plan of the excavations at St Michael's Street in 1985. (Modified after A. Dodd (ed.), 2003, p. 141, Figure 4.4)

Over time a number of the earthen ramparts of these burhs were refaced with stone, usually either of dry stone construction or poorly mortared stone. Archaeologists remain divided over when these reinforcements are likely to have been added; for example, Jeremy Haslam has argued for an early tenth-century date, while others continue to support the model put forward by C. A. Raleigh Radford, who in the 1970s argued that the stone walls were part of a concerted programme of defensive improvements initiated during the reign of Æthelred II, the Unready (*c.* 968–1016). To date only eight burhs have produced convincing evidence for the addition of pre-Norman Conquest stone defences, excluding repairs to existing Roman walls, these being South Cadbury (Somerset), Hereford, Tamworth (Staffordshire), Oldport (Devon), Winchcombe (Gloucestershire), Christchurch (Dorset), Southampton and Oxford.

As we have already seen in Dig 2, evidence for a rampart faced by a stone wall at Oxford was encountered at the Clarendon Quadrangle investigations in 1899. Another rare opportunity to examine the defences arose in 1985 when a new building and cellar were constructed at No. 24a St Michael's Street, now the showroom for Mallams Auctioneers. This was a site that had long been considered a promising location as it was the only plot along the street where buildings had not been fully extended over the northern line of the defences. Here a wall and outer ditch protected the most vulnerable part of the town facing the gently rising gravel terrace. To the south, east and west natural defences were provided by the Thames and Cherwell rivers and the ditch was not extended along the southern part of the defences for this reason. In the seventeenth century the northern ditch was filled in and the open strips of land either side of the wall became available for building.

The St Michael's Street excavation, led by Peter McKeague for the Oxford Archaeological Unit, revealed the Late Saxon rampart and discovered that traces of the wall built to reinforce it had survived the major thirteenth-century rebuilding of the town wall. For the first time a clear construction sequence was revealed. The rampart had been built over a fallow field that had not been under a crop for several years.

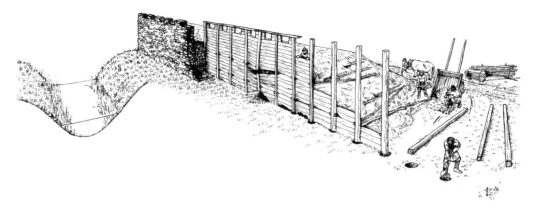

Reconstruction of the Late Saxon rampart showing the initial timber revetment, the use of lacing timbers to bind the rampart of turf, loam and gravel, and the later bowing of the wooden planks and subsequent reinforcement with a stone wall. (Reproduced courtesy of Brian Durham)

A spread of clean gravel was laid down and more was tipped over this from south to north. Over this a mound of loam was dumped and a stack of silty clay, probably made up of turves, formed the front of the rampart. Over the clay and gravel base horizontal 'lacing' timbers were placed and then sequential tips of gravel and turf lines were added above. The construction showed that loam and gravel had not simply been thrown up from the nearby defensive ditch, but that considerable effort had been made moving and storing materials and then adding them in a planned sequence. Unfortunately, later development had removed the rear part of the rampart, leaving only 7.65 metres of its width. It survived up to a height of 1.6 metres. The front of the rampart produced traces of a vertical wooden revetment that had reinforced the original turf bank and this had later been reinforced by a thick stone wall.

The wall later added to the front of the rampart was bonded with crude lime-free mortar and was subsequently rebuilt, probably in the early thirteenth century. Work further to the east at St Michael's at the Northgate has shown that an open space or 'berm' separated the wall from the town ditch located 6 metres to the north. Running parallel along the inside of the rampart, and following the approximate line of St Michael's Street and Ship Street, would have been a trackway to allow the rapid deployment of fighting men. Based on the distance of the excavated retaining wall from the line of St Michael Street, and on the identification of a drainage ditch that separated the rampart from the early track, the rampart must have measured between 7.5 and 13 metres in width, with an estimated original height of 2.5 metres. The 1985 dig was not able to conclusively date the rampart and initial facing wall but it did rescue a crucial snapshot of the defensive sequence before modern development removed the evidence (see Dig 10).

Dig 9

The Earliest Town Dweller?

Christ Church Cathedral Graveyard, 1998

The early origins of Oxford in the Middle Saxon period are captured in a foundation myth that was written down in three separate accounts in the twelfth century. The story places Oxford's origins back in the seventh to eighth centuries, when it may have been carved out of a large royal estate centred at Headington. The accounts tell that a sub-king of the Mercians called Didan ruled the Oxford area and had a very pious daughter called Frideswide. Didan founded a church, and Frideswide then founded a community of nuns and became abbess. When Didan died, Frideswide was pursued by King Algar of Leicester, who wanted her hand in marriage; she evaded him and with the help of miracles fled along the River Thames to Bampton. When Algar arrived at Oxford he was struck blind for his sins and returned home. After three years away, during which time she performed a number of miracles, Frideswide returned to Oxford and remained there until her death, which one account precisely records as being on 19 October 727.

The earliest documentary reference for a church at St Frideswides, the site of the current cathedral at Christ Church, is a charter of Æthelred II of 1004. However, historians such as Revd H. E. Salter, F. M. Stenton and others have suggested that the

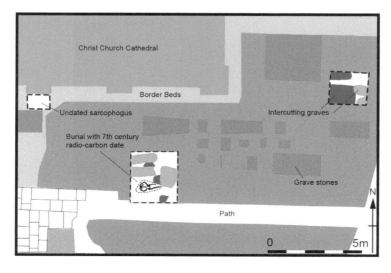

Plan of the excavations in Christ Church Cathedral Graveyard in 1998. (Modified after Boyle et al., 2002, 'Excavations in Christ Church Cathedral Graveyard', *Oxoniensia* 66: 338, Figure 1)

later twelfth-century accounts of St Frideswide could well represent a garbled memory of an earlier religious settlement, perhaps a minster church, located near to the Thames river crossing. In the twelfth century an Augustinian Priory was founded at the site of the earlier church and this may represent the re-foundation of a religious institution of some antiquity. The twelfth-century priory church now forms the core of the city's cathedral.

From around the town we have fragmentary evidence of settlement activity that predates the emergence of the burh in the late ninth or early tenth century. An eighth-century coin of the Mercian King Offa the Great was found near the Martyrs Memorial on St Giles. Nearby a few sherds of imported eighth-century Ipswich Ware pottery have been recovered from excavations at the Sackler Library and the nearby Ashmolean Museum. To the south of the town along St Aldate's the remains of a possible Middle Saxon causeway have been recovered, with associated settlement rubbish and also wattle-lined gullies containing flax seeds, the latter pointing to the soaking of flax for combing and weaving into cloth.

Archaeologists have also undertaken targeted excavations in the cathedral precinct and at the nearby sites of Corpus Christi College and St Aldate's Church. Together these investigations have produced evidence for a zone of burials following the edge of an east–west gravel scarp overlooking the Thames floodplain and belonging to a community that was established by the ninth or tenth century and possibly earlier. The scarp here, overlooking the floodplain and crossing, would have been more distinct in Saxon times as the modern topography reflects episodes of medieval land raising and the extension of the priory precinct southwards in the twelfth century.

These burials, some placed on distinctive 'beds' of charcoal, perhaps reflecting early notions of cleanliness and purity, are likely associated with the Saxon predecessors of St Aldate's Church and Christ Church Cathedral, although it is curious that burials have also been found beyond the extent of the historic graveyards of both foundations. To the east a burial radiocarbon dated to the eighth to tenth century was recorded in 2008 within the footprint of the new Music Room at Corpus Christi College and to the west two undated skeletons were observed outside the entrance gate of Pembroke College in 1960.

Of all the investigations in this area the most striking results were produced by trenches excavated in the summer of 1998 in advance of an extension to the Christ Church Cathedral Graveyard. The trenches, excavated under the direction of Angela Boyle for the Oxford Archaeological Unit, recovered thirty-seven skeletons of likely Late Saxon date, mostly men but including at least three females. Some of the graves were lined with stone and one body had stones placed by each ear, so-called 'ear-muffs' that are sometimes found in ninth to twelfth-century burials. There is no documented explanation of the practice but it may reflect the concern of the deceased that their head should be firmly fixed so that it would face directly east when the body rose again on Judgement Day. The practice appears to disappear in the late twelfth to early thirteenth century when the concept of purgatory began to be more widely promoted by the Church.

Three of the skeletons from the Christ Church dig were subject to radiocarbon dating, with the most surprising result coming from the skeleton of a woman around the age of forty. Her remains produced a seventh-century radiocarbon date with a high level of confidence. While the burial cannot be treated as conclusive proof of a religious community dating back to the Middle Saxon period in this location, it suggests that the story of Oxford's early emergence remains to be rediscovered, perhaps in and around the site of its cathedral.

Dig 10

The Western Burh

Oxford Castle, 2003–5

Oxford Castle was built in 1071 by Robert d'Oilly, the Norman strongman given charge of the town by William the Conqueror. Initially of simple motte and bailey type, it was built over land previously occupied by streets and halls in the west end of the town. It was no doubt designed to send a clear message to the townsfolk regarding who was now in charge while leaving the commercial heart of the town around the Carfax crossroads intact. Subsequently, the castle site evolved as a stronghold, administrative centre and county prison.

In 1952 E. M. Jope first tested the idea that earlier stratified deposits might survive below the Norman motte and subsequent excavations in the 1960s and 1970s directed by Tom Hassall recovered important information about earlier Saxon levels and the medieval barbican and moat. A further major opportunity to investigate the former centre of military and legal authority in the town came with the closure of the prison in 1996 and the subsequent redevelopment of the Castle Quarter, involving the construction of a number of new buildings and the renovation of many of the eighteenth and nineteenth-century prison buildings. The ensuing archaeological excavation of the new building footprints was undertaken by Oxford Archaeology under the direction of Dan Poore between 2003 and 2005. On completion the converted prison cell block became an upmarket hotel and the Norman motte and adjacent St George's Tower and crypt were leased by Oxford Preservation Trust to become part of the Oxford Castle heritage attraction.

Inside the line of the Saxon and later Norman defences, the dig recorded arrangements of posts and pits belonging to sequences of Saxon halls and patches of metaling indicating street or yard surfaces. Pottery recovered from this area included Stamford Ware imported from the Midlands in the late ninth and early tenth century. The excavators also cut sections though the grey clay of the Norman ramparts to find the remains of the Late Saxon ramparts below. This was potentially an opportunity to demonstrate whether the western part of the town had always been located within the original defended burh or whether the nearby settlement remains belonged to a suburb located outside the early defences. Unfortunately, dating the Saxon rampart proved to be an elusive goal. Instead, the castle dig added to the puzzle by demonstrating the presence of a possible two-stage rampart composed initially of turf and then dumped refuse, running towards the later St George's Tower, which itself may pre-date the Norman Conquest.

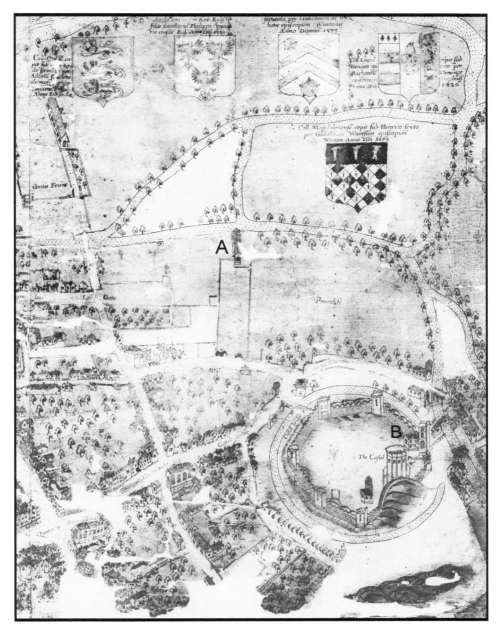

Part of Agas's map of Oxford, made in 1578 and engraved in 1588 (south is at the top). The site of the Greyfriars is labelled 'A'. Only forty years from its Dissolution, the precinct has already been largely dismantled save for a single building. Agas mistakenly labelled the site of the Dominican Friary, or Blackfriars, as the site of the Greyfriars (top left). The site of the Castle excavation is labelled 'B'. (Reproduced courtesy of the Oxford Historical Society)

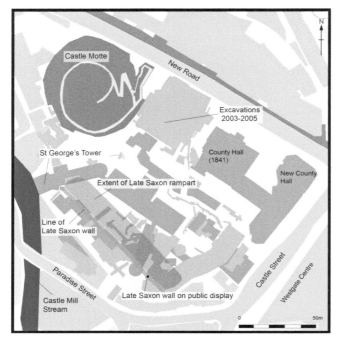

Plan of the Oxford Castle excavations 2003–5 showing the location of the Late Saxon burh wall, which is on public display. (Modified after Oxford Archaeology, The Oxford Castle Excavations, draft publication, Figure 1.3)

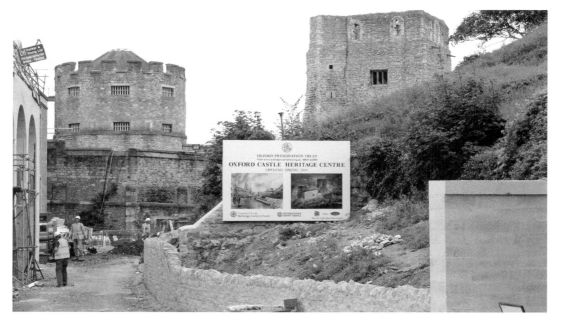

View of the Norman castle motte (right), the Late Saxon or Norman St George's Tower (centre right) and the eighteenth-century Debtor's Tower forming part of D Wing (left). The photograph shows the Castle Quarter under construction in 2005. (Reproduced courtesy of Oxford City Council)

A close look at the excavation records by Anne Dodd has established that the upper part of the Saxon rampart at the castle site was made up of loose dumped soil that contained domestic rubbish including pottery of late tenth to eleventh century date. Did this prove that the western part of the burh defences date to this period? Dodd is cautious as the bottom part of the compacted turf rampart contained no datable finds, perhaps suggesting that there had been two phases of rampart building, thus leaving open the question of whether the nearby Saxon halls were located outside of the original burh. Perhaps the strongest evidence for a primary burh having encompassed both the centre and western part of the settlement was the absence of tenth-century rubbish pits and quarry pits under the rampart itself and the lack of pottery from within its base, a curious outcome if the rampart had been added around an extramural settlement that had been producing waste for some considerable time.

During the excavation the stone town wall that had been built along the front of the Saxon rampart was examined in two locations. In one section the face of the rampart had been crudely cut away and the wall inserted, its face bonded with lime mortar (this part of the Saxon wall remains on public view at the Castle Quarter). In the other section, located next to St George's Tower, the wall had been inserted into the rampart within a neat straight sided trench (a process sometimes described as 'trench built'), in the process cutting through the remains of two skeletons that had been buried in the rampart.

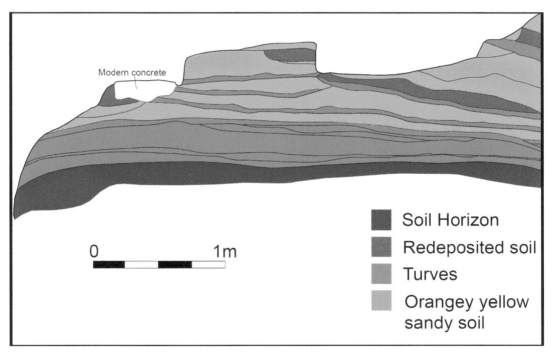

A south-west to north-east section through the Late Saxon rampart showing the bottom layers of compacted turf and the upper layers of turf and soil that contained much early eleventh-century pottery. (Modified after Oxford Archaeology, The Oxford Castle Excavations, draft publication, Figure 2.11)

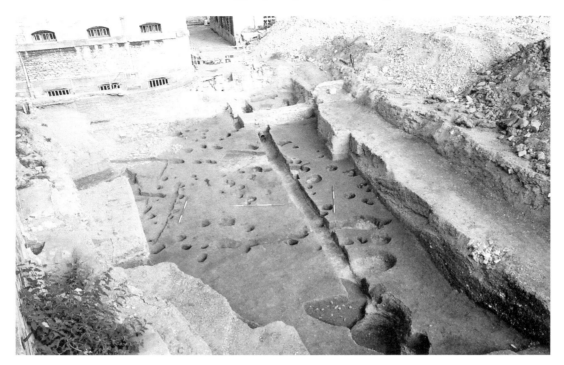

View looking north-east across the C Wing excavation, showing arrangements of Late Saxon post holes and beam slots belonging to former buildings. The former eighteenth-century C Wing of the prison lies just off camera to the left. The visible buildings are the nineteenth-century A Wing (top left) and Governor's Office (to the right of the passage). (Reproduced courtesy of Oxford Archaeology)

The radiocarbon dates for these skeletons placed them in a date range from the late tenth or early eleventh century. One might therefore propose, as Anne Dodd has done, a scenario whereby an existing rampart is improved around the time when there was a heightened threat of Viking attacks in the early eleventh century, but that for a time the defensive role of the rampart diminished and it was used for burials. The excavation near to St George's Tower appears to show that a stone retaining wall was added to the rampart only after the burials took place; however, it remains possible that this section of wall represents a localised repair of an earlier wall on a more southerly alignment.

The Late Saxon layers at the castle excavation were relatively well preserved because of their depth below the modern ground level. Unfortunately, the medieval layers above had been extensively removed by later activity, although fragments of buildings survived; for example, a small section of masonry that may have belonged to the Shire Hall. There were further surprises from the post-medieval levels which produced a grizzly reminder of Oxford prison's brutal history. When the archaeologists excavated part of the motte ditch they encountered the poorly interred remains of prisoners from the castle prison dating to the sixteenth, seventeenth and eighteenth centuries. Many of the skeletons showed evidence of malnutrition, and at least fifteen individuals who had been executed had parts of their anatomy removed. In the seventeenth century the University played

an important role in the development of anatomical science and was home to a number of renowned anatomists, including the scientist Robert Boyle (1627–91), who pioneered the technique of preserving specimens in alcohol. It is likely that the castle bodies had their organs removed by the anatomists of the Old Ashmolean Museum, Christ Church and other colleges for research and teaching purposes. The bodies were then returned for burial.

The skeletons of the inmates from the prison cemetery included at least five individuals who were between the ages of twelve and fourteen, illustrating the harsh social values of the day relating to punishment. Perhaps the most touching discovery was the remains of the skeleton of a teenage boy found clutching a worn coin of Elizabeth I and a shred of fibre in his clenched right fist. The clenching of the fists is a natural reflex during hanging. Evidently this individual was grasping a coin through his pocket in his final moments on the scaffold.

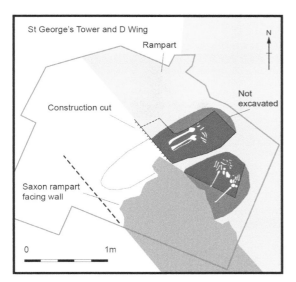 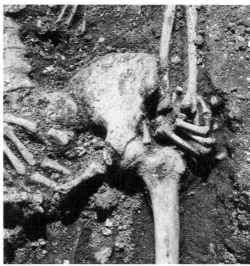

Above left: Plan of the two burials dug into the Late Saxon rampart near St George's Tower. These were radiocarbon dated to the late tenth and early eleventh centuries and were cut through by a stone wall built to reinforce the rampart. (Modified after Oxford Archaeology, The Oxford Castle Excavations, draft publication, Figure 2.17)

Above right: The skeleton of a young adult (aged between eighteen and twenty-five, probably male). The skeleton was uncovered in the motte ditch and is dated to the seventeenth century. The hand is grasped, probably as a reflex response to hanging, and the body showed signs of craniotomy and cut marks, indicating post-mortem dissection. (Reproduced courtesy of Oxford Archaeology)

Dig 11

The Big Bridge

Abingdon Road, 2004

The Domesday Survey of 1086 lists a considerable number of properties in Oxford as 'waste'. If this is a reflection of a temporary decline in the town's fortunes post-Conquest, then recovery was not long coming. By the late eleventh century the economy was reviving and significant funds were being directed into new building projects, including the construction of a massive stone causeway across the Thames floodplain. The monks of Abingdon Abbey recorded in their Chronicle that Robert d'Oilly constructed this great bridge, or Grandpont, running south from the walled town down modern St Aldate's across the River Thames at Folly Bridge and along the Abingdon Road, following a route that may have made occasional use of some pre-existing Saxon or even Roman structures. A map of *c.* 1569 belonging to Brasenose College shows the causeway with at least seventeen round-headed arches.

Evidence that this 'big bridge' was made of stone and substantially preserved, both under existing roads as well as within the fabric of the surviving Folly Bridge, was gathered together by Brian Durham in the late 1970s and early 1980s. Previously there had been no proof that the surviving stone arches and causeway of the Grandpont dated back to d'Oilly's time and some had argued that the structure referred to by the

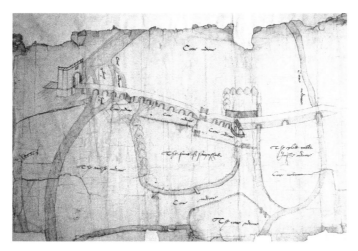

The sixteenth-century Brasenose College map of the Grandpont Causeway, showing the gatehouse and drawbridge that was located at the southern end of the current Folly Bridge. A series of seventeen stone arches are shown south of the drawbridge. (Reproduced courtesy of The Principal and Fellows of Brasenose College, archive ref. B13.4)

View looking north along Abingdon Road, showing the exposed top of a stone arch (the straight line of stonework represents the western edge of the arch) and associated metalling. (Reproduced courtesy of Brian Durham and Oxford City Council)

monks of Abingdon would have been made of wood. No other directly comparable and contemporary stone causeways are known to survive in northern Europe. The spectacular nine-pillar stone bridge at Trier, still in use, is Roman in date and the impressive stone bridge over the Rhône at Avignon was built in the twelfth century.

The work of Durham and his colleagues in the 1970s produced convincing evidence that the Grandpont causeway was built in stone in the eleventh century by demonstrating that a nearby Late Saxon ford was abandoned at this time and that subsequently thick layers of silt accumulated, pointing to the presence of a large stone barrier across the floodplain and not a wooden bridge. The causeway was shown to be an elevated trackway comprising consolidated rag stone rubble, mortared ashlar bocks, sometimes with a cobbled surface and with intermittent piers and vaulted stone arches to let the Thames channels and periodic floodwater pass under. The 4-metre-wide causeway ran for at least 700 metres south of the junction of St Aldate's and Speedwell Street. South of the town gate the route crossed a bridge over the Trill Mill stream and the Shire Lake channel before reaching the south bridge over the main channel of the Thames, now Folly Bridge, where a gatehouse with a drawbridge was located in medieval times. If you punt around the back of Folly Bridge you can still see the Norman arches in a couple of places under the road to the south. From here the causeway headed south and then west across the floodplain, perhaps intermittently, as some islands of higher gravel may not have required an elevated trackway.

In 2004 an opportunity arose to investigate the remains of the causeway along Abingdon Road, south of Folly Bridge, during road repair works by the County Highways Department. Recording was undertaken by a team led by Jamie Preston, working for the Jacobs Babtie Environmental Consultancy. The works were intended to secure the protection of the causeway below new road improvements and used Ground Penetrating Radar to identify the locations where the causeway arches might be impacted. A series of archaeological trenches revealed the surface of the stone causeway and the tops of several arches, along with a sequence of later surfaces and repairs above.

Although it only involved small interventions, the project provided a rare glimpse of this truly monumental structure and a greater understanding of the legacy of those who

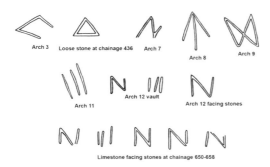

Catalogue of mason's marks from the Grandpont Causeway (not to scale)

Mason marks recorded from the exposed stonework during the 2004 works. (Modified after J. Preston, 2005, Figure 21)

An inspection of the exposed mitred stone arch belonging to the Grandpont Causeway, located close to Edith Road. (Reproduced courtesy of Brian Durham and Oxford City Council)

built it. Within the vaulted culverts the distinctive striated diagonal tool marks of the Norman masons could be seen. This method of working stone was a common technique until around 1200 and was the result of a mason using a wide multi-toothed chisel that produced parallel score-marks. A further personal reminder of the Norman builders was left in the form of a range of symbols, letters and Roman numerals carved into the facing stones and voussoirs of the archways. The Roman numerals were probably added to the stone on the mason's bench to record piecework.

 The investigation recorded twelve arches; eleven of these proved to have round-headed vaults but one had a distinctive pointed or mitred arch. This style of arch is known to have been used in Normandy in the eleventh century, as well as being more common in Late Saxon architecture. Why only one arch should be built in this fashion is unclear; perhaps a mason who favoured this style of architecture was employed to build this section of causeway. During the Middle Ages the causeway was subject to the upkeep of the town authorities and also neighbouring Berkshire, within which the bulk of the causeway was located until local government re-organisation in 1974. The massive structure would have been under the supervision of bridge hermits and bridge-wrights and would have been periodically widened and repaired. The full complexity of its fabric and character remains to be explored.

Dig 12

Backstreet Experiments

Christ Church, Peckwater Quad, 2005–6

The earliest surviving map of Oxford by land surveyor Ralph Agas, drawn in 1578, can give a slightly misleading impression of the density of earlier urban settlement because it records the town in a period of relative economic decline. If you combine the map evidence with the town's rich legacy of documentary records that stretches back to the twelfth century, as was done with great skill and success by the historian Revd H. E. Salter in his *Map of Medieval Oxford* (1935) and posthumously published volumes (*Survey of Oxford* I and II; 1960 and 1969), a much denser and complex medieval town is revealed.

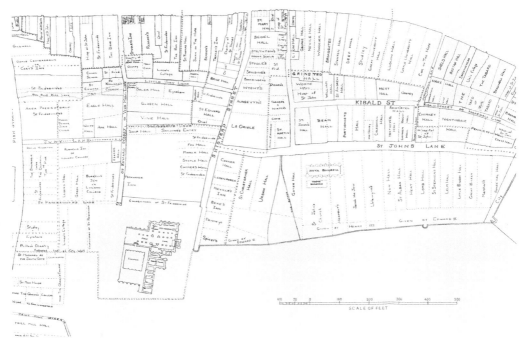

Part of the Revd H. E. Salter's Map of Oxford, showing the locations of medieval tenements based on an interpretation of documentary records and later maps. The site of Vine Hall is labelled to the east of St Edward Street. (Reproduced courtesy of the Oxford Historical Society)

The potential for this lost landscape to provide new surprises was demonstrated by an archaeological investigation during the excavation of a trench for IT cables through the grounds of Christ Church undertaken by John Moore Heritage Services between 2005 and 2006. When the trench passed through Peckwater Quad – one of the grander quadrangles of the University Colleges that is framed by impressive eighteenth-century ranges built in Italian Renaissance style – it revealed that when the quad had been laid out it had fossilised the medieval landscape below. The surfaces of medieval St Edward Street and Shitebarn Lane were uncovered and along them the remains of stone-built halls dating from the fourteenth century.

These buildings survived up to five stone courses high, preserving a number of distinctive features such as front door steps and patches of pinkish-white mortar surviving on internal walls. The most surprising discovery was a stone-lined toilet (or garderobe) into which a collection of early fourteenth-century waste had been thrown. The pit contained an exceptional collection of ceramic vessels and glass distilling equipment that included ceramic skillets (like a pottery frying pan), cruets, bowls and bottles complete with clay plugs, as well as glass tubing and containers used for heating liquid and capturing condensed liquid (known as alembics). Also present were fragments of fired clay belonging to a portable oven or furnace. Some of these artefacts preserved traces of residues on internal surfaces, evidence for the use of acidic substances and use at high temperatures.

The glass and pottery specialists who looked at the assemblage, Rachel Tyson and Paul Blinkhorn, noted that it was the earliest group of objects of its kind yet discovered in

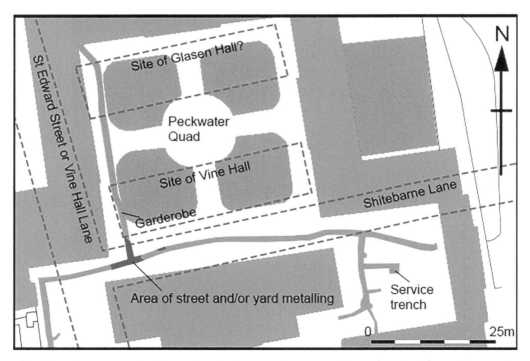

Plan of Peckwater Quad, Christ Church, showing the route of the IT trench observed during the 2005 works. (Modified after A. M. Chadwick et al., 2012, p. 37 Figure 18)

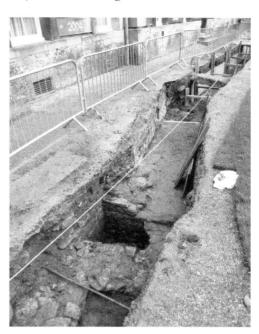

Peckwater Quad looking north, showing the stone-lined pit in the IT trench, which contained the early fourteenth-century pottery and glass assemblage. (Reproduced courtesy of Brian Durham and Oxford City Council)

England and that the remains and their high temperature use did not correspond to any of the more mundane recorded functions of such distilling apparatus. They suggested that the artefacts may have been used for alchemical related experimentation, a practice that Oxford scholars such as thirteenth-century Franciscan friar Roger Bacon certainly wrote about, but for which little physical evidence has been discovered. Bacon claimed to have spent 2,000 French pounds on alchemical research (an enormous amount by medieval standards). He wrote about the importance of alchemy in his book *Opus Maius* but there is little information that survives about any practical experiments that he may have undertaken.

Alchemy was the medieval forerunner of chemistry, and was concerned with the transmutation of matter, in particular with attempts to convert base metals into gold or find a universal elixir to cure disease and prolong life. In the Middle Ages alchemy was a mixture of science, philosophy and mysticism; its role in the development of the discipline of chemistry is largely ignored in formal histories of the University and it was never taught as a subject, being far too secretive and mistrusted an art. Nevertheless, the boundaries between alchemy and experimental chemistry were blurred and there is evidence for the practice in Oxford from a collection of seventeenth-century crucibles found at the back of the Old Ashmolean Museum on Broad Street. These were subject to residue analysis by the archaeological scientist Marcos Martinez-Torres and shown to have been used for experiments with mercury and sulphur. Further residue analysis of the Peckwater Quad finds may clarify what substances were heated and manipulated using this distinctive equipment; for now we can speculate that the very College where parts of the *Harry Potter* film franchise were made has provided Oxford with its very own medieval alchemy kit!

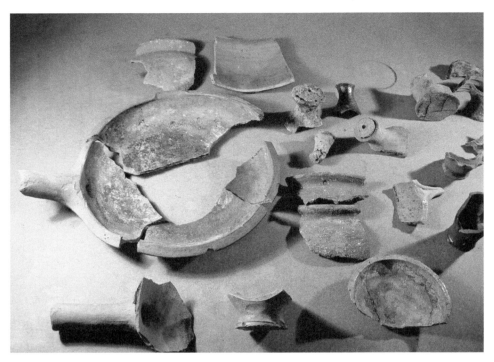

Part of the early fourteenth-century ceramic assemblage from the stone-lined pit in Peckwater Quad. The pottery was mostly the produce of the nearby Brill and Boarstall pottery industry located just across the county boundary in Buckinghamshire. The large frying pan type object is a skillet. Parts of vitrified ceramic jars, still sealed by clay plugs, are pictured top right. (Reproduced courtesy of John Moore Heritage Services)

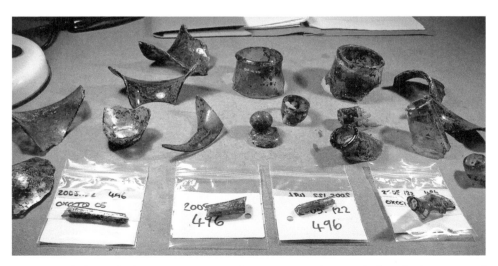

Selection of the early fourteenth-century glass alembic tubing and glass flasks recovered from the stone-lined pit in Peckwater Quad. (Photograph by author)

Dig 13

A Viking Raiding Party?

St John's College, Queen Elizabeth House, 2008

In 2007 archaeologists were brought in to dig evaluation trenches on the site of a proposed accommodation block at the former Queen Elizabeth House site belonging to St John's College. The site was located on the eastern side of St Giles in Oxford's northern suburb and the trenches identified the remains of eleventh-century pits belonging to the sparsely occupied plots that had once fronted onto the northern end of the street. The investigation suggested that during the twelfth century activity in this area had declined and then intensified again a century later with dense arrays of rubbish pits located within new narrow plots. In the fourteenth century these plots seem to have

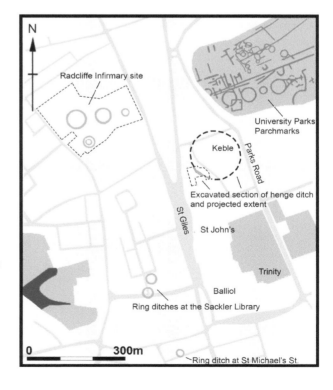

Plan showing the location of the 2008 excavation at the Queen Elizabeth House site, St John's College, St Giles. The projected extent of the Neolithic henge is shown, along with the extent of the ring ditches excavated at the former Radcliffe Infirmary site (top left) and the parch marks recorded in University Parks (top right). The sites of other partly excavated ring ditches are shown at the Sackler Library and St Michael's Street. (Modified after S. Wallis, 2014, Figure 2.1)

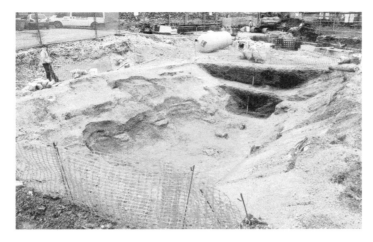

An excavated section of the Neolithic henge looking east, with scallop-shaped holes visible along the bottom inner face of the ditch, which would have been excavated with antler picks. (Reproduced courtesy of Thames Valley Archaeological Services)

been amalgamated when the area became part of Blackhall Farm. The development site was also pockmarked with gravel quarry pits likely of Victorian date. Such quarry pits provided material for the surfacing of quads, yards and paths and are common features across the College holdings north of Oxford. Planning permission for the new Kendrew Quad accommodation block was subsequently obtained with a planning condition requiring that archaeologists return to excavate the site.

It therefore came as somewhat of a surprise in 2008 when archaeologists from Thames Valley Archaeological Services (TVAS) led by Sean Wallis and Jo Pine were employed to excavate the anticipated medieval and later remains and discovered that one on the pits was not a gravel quarry after all. The feature turned out to be a large U-shaped ditch some 2.5 metres to 2.9 metres deep, between 5 metres and 8 metres wide and at least 62 metres in length. It formed part of a large sub-oval monument that could be projected to occupy an area of about 150 metres in diameter running under nearby Keble College. This massive monument, complete with antler picks left within the scallop-shaped holes at the base of the ditch, was a major henge monument of Late Neolithic date.

Such monuments generally have a characteristic outer bank that makes them more likely to have been used for gatherings and religious events than for defence. No trace of a bank was recorded at the St John's site and it is likely that this had been removed by later activity. What can be said with some confidence is that the ditch remained a feature in the landscape for the next three millennia. This was demonstrated by another surprise discovery – a mass grave of between thirty-five and thirty-seven young men, mostly between the ages of sixteen and twenty-five, who had been brutally killed with a variety of weapons, stripped of their clothes and unceremoniously thrown in one on top of another without reverence. The positions of the skeletons showed that they had been dumped into the ditch of the henge before rigor mortis had set in.

Subsequent radiocarbon dating of selected bone samples indicated that these men lived and died between the late eighth and early eleventh century. Isotopic analysis measuring the ratio of carbon and nitrogen in the bone marrow indicated that a number of the victims had grown up eating more fish than is usual for the local population. While salted sea fish and freshwater fish may have been traded in Oxford, such readings suggested that the men had for a time lived closer to the sea. Taken together with results

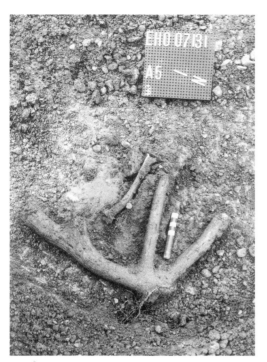
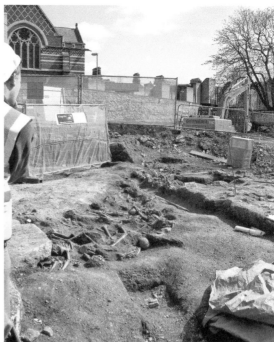

Above left: Neolithic antler pick found in the base of the henge ditch. (Reproduced courtesy of Thames Valley Archaeological Services)

Above right: View of the mass grave at the Queen Elizabeth House site looking east. The radiocarbon dates from the burials suggest that the grave dates to a single violent episode between the late eighth century and early eleventh century, probably towards the end of this date range. (Reproduced courtesy of Thames Valley Archaeological Services)

of analysis of the teeth enamel, which showed that a number of the individuals appear to have grown up in a colder climate, it is possible that the mass grave represents the outcome of a violent episode between the local population and men of Scandinavian origin, perhaps Danish settlers or alternatively raiders.

Opinion is divided regarding what that event might have been. The excavators point out that in AD 1002 King Æthelred the Unready ordered that Danish settlers who had integrated into local Saxon communities, 'sprouting like cockle among the wheat', be exterminated. This brutal instruction took place in a charged atmosphere created by the intensification of Viking raids during the 990s. One such massacre is recorded at Oxford. A twelfth-century account of the AD 1002 events, known as the St Brice's Day Massacre, records that Danish residents of Oxford were brutally attacked and killed, with some seeking refuge in St Frideswide's Church, which was then burnt by the townsfolk.

Steve Preston of TVAS suggests that as the wounds suffered by the victims in the mass grave were received from multiple angles, notably to the legs and from the rear, this would not be consistent with either face to face combat or warriors wearing defensive

Blade and projectile wounds to the top of a skull from the mass grave at the Queen Elizabeth House site, St John's College. (Reproduced courtesy of Thames Valley Archaeological Services)

armour in battle and therefore could represent wounds inflicted in the massacre. However, it was noted that some of the wounds received from behind could have been sustained if a fighting line had been broken by the enemy and the combatants had been struck down while they fled. Some of the human remains showed traces of burning, thus offering a further possible link to the St Brice's Day Massacre story.

An alternative explanation has been suggested by Professor Mark Pollard and colleagues at the Oxford University Research Laboratory for Archaeology and the History of Art (RLAHA) who undertook the isotopic analysis of the bones and teeth. The RLAHA team note that the victims were all robust tall men, many with healed wounds that we would expect of professional warriors, perhaps suggesting, taken alongside the scientific evidence, that the group might represent a Viking raiding party.

The survival of the massive henge monument as a visible feature into the late-Saxon period probably explains the nearby routes of Banbury Road and Parks Road which fan around the now buried henge ditch. Over time the ditch filled up, eventually its upper layer taking on the appearance of a ring-shaped depression. To the Christian town dwellers of Late Saxon Oxford, it must have represented a profane and pagan place, perhaps explaining why it was chosen as the location for this macabre mass grave.

Dig 14

Putting the Ox into Oxford?

The Radcliffe Infirmary, Woodstock Road, 2009

In 2009 the University cleared the former National Health Service buildings from the Radcliffe Infirmary site in north Oxford and a large open area excavation was undertaken by Museum of London Archaeology in advance of the construction of new University department buildings and the refit of the eighteenth-century infirmary, nineteenth-century chapel and early twentieth-century outpatients building. The excavation, directed by Tim Braybrooke, investigated the remains of the infirmary outbuildings and water supply structures, including the 1770 laundry building, the soakaway of which produced large quantities of late eighteenth to early nineteenth-century hospital-related rubbish, including tableware bearing the hospital's name and drinking vessels. The latter are commonly found in medieval and post-medieval pottery assemblages from across the town and are evidence not just of the drinking culture that came with student life, but also of the pragmatic use of ale as part of the calorific intake of labourers tasked with building and maintaining the town's grand College and civic structures. Similarly, the nurses of the infirmary and certain patients were given daily allocations of ale, hence the need for an on-site brew house, the site of which was tentatively identified to the south of the laundry.

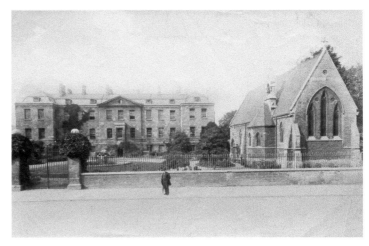

View west across the Woodstock Road, towards the Radcliffe Infirmary, which was designed by Stiff Leadbetter and built between 1759 and 1770. To the right is the hospital chapel of St Luke by A. W. Blomfield, built in 1865. (Henry W. Taunt, 1890, reproduced courtesy of the Oxfordshire County Council Photographic Archive, HT6206)

View from the Radcliffe Infirmary looking west across the former hospital buildings before demolition; the central building with the high roof is the old operating theatre, built in 1899. (Reproduced courtesy of Oxford City Council)

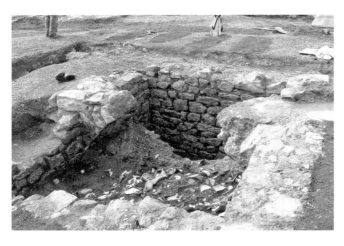

Remains of the soakaway serving the 1820s infirmary laundry and containing a large dump of pottery and hospital waste. (Reproduced courtesy of Oxford City Council)

An archaeologist from Museum of London Archaeology holding a fragment of delftware ointment pot painted 'WALKER OXFORD' after Richard Walker, who was apothecary at the Radcliffe Infirmary between 1781 and 1805. Such pots would have been used for cold creams. (Reproduced courtesy of Oxford City Council)

The large infirmary site was also of interest for its potential to preserve prehistoric archaeology. In the dry summer of 1976, aerial photographs taken of the University Parks, located further to the east, enabled Don Benson, David Miles and Tom Hassall to identify parch marks that appeared to be the remains of ring ditches and Iron Age and Roman fields. Some of the ring ditches appeared to form an alignment and Hassall suggested that these might be the remains of a linear barrow cemetery of Late Neolithic to Early Bronze Age date. The line of the cemetery could be projected westwards across the Oxford gravel terrace towards the Radcliffe Infirmary site.

These ring ditches formed part of an extensive complex of associated mounds, enclosures and satellite burials located across the Oxford gravel terrace. This complex in turn formed part of a wider pattern of similar 'funerary and ritual' landscapes spaced intermittently along the Upper Thames. These landscapes appear to be places for semi-nomadic prehistoric communities to meet, honour and bury powerful or respected individuals, exchange gifts for prestige and partake in communal feasting. They may also have been places where sexual and life partners could be found and knowledge exchanged.

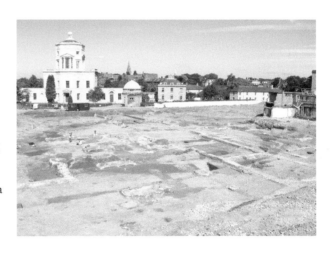

View looking north across one of the Bronze Age ring ditches, located in front of the 1772 Radcliffe Observatory. The building functioned as an observatory from 1773 until the Radcliffe Trustees decided to sell it in 1934 and erect a new observatory in Pretoria, South Africa. (Reproduced courtesy of Oxford City Council)

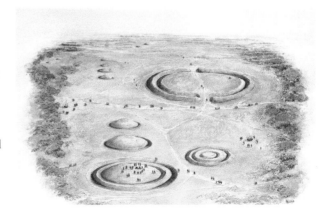

Reconstruction drawing by Faith Vardy looking east across the Oxford gravel terrace and depicting the Neolithic henge at St John's College (top right) and the Bronze Age linear barrow cemetery that runs through University Parks and the Radcliffe Infirmary site. A burial ceremony is depicted as taking place within the largest ring ditch. (Reproduced courtesy of Museum of London Archaeology)

Additional evidence for prehistoric archaeology in the vicinity of the former hospital was provided by a twelfth-century title deed that records the 'croft of the three barrows' to the west of the Woodstock Road and also the seventeenth-century observations of Dr Robert Plot, the first keeper of the Ashmolean Museum, who wrote enigmatically about rectangular and circular marks visible in the vegetation in fields north of Oxford. He suggested that these were perhaps the result of lightning strikes 'exploded from the clouds, most times in a circular manner'.

These observations were confirmed by the 2009 excavation. Four large ring ditches, presumed to be former barrows, showed up clearly with their reddish-brown fills of redeposited terrace loess standing out against the yellowy-grey terrace sands and gravels. Three large ring ditches, between 45 and 60 metres in diameter, continued the line of the linear cemetery from the University Parks. Another double barrow located further south, 35 metres in diameter and comprised of concentric ditches, was perhaps part of a parallel arrangement of earthworks or a satellite structure. One can speculate about whether the linear axis related to some form of processional way of which this outer barrow formed part.

A great deal of effort was expended seeking to understand the character of the landscape between the barrows as such spaces may contain the remains of satellite burials and ephemeral structures built of wood; however, while a large number of small pit-like features were recorded, these proved very hard to date or characterise. The exceptions were two Bronze Age cremations found within the most westerly ring ditch, one of which appeared to have been buried in a bag, presumably of leather,

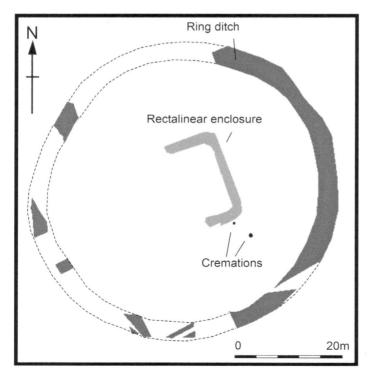

Plan of the most westerly Bronze Age ring ditch at the Radcliffe Infirmary site, with associated cremations and the remnants of the Middle Neolithic sub-rectilinear enclosure located within it. (Modified after T. Braybrooke, 2011, Figure 9)

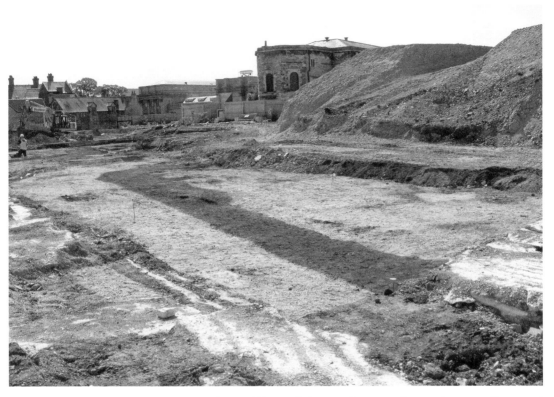

View looking south-west across the Middle Neolithic rectilinear enclosure that was discovered within the most westerly Bronze Age ring ditch. The rear of Freud's café on Walton Street (formerly St Paul's Church) can be seen in the background. (Reproduced courtesy of Oxford City Council)

which had long decayed away, leaving a concentration of burnt bone. An animal bone from the primary fill of the nearby ring ditch produced a calibrated radiocarbon date of 1890–1690 BC, and one of the cremations a calibrated date of 2030–1870 BC, providing an indication of the broad period of use of this complex.

The excavation showed that the large earthwork mounds and the space cleared of woodland around them appear to have been respected in the landscape until fields and droveways were established in the Middle Iron Age period. By this time the local population had grown large enough to see such sites as desirable spaces for settlement and agriculture: the power of the ancient landscape to exact fear or respect appears to have finally diminished.

The excavation produced one last surprise. Within the most westerly ring ditch in the linear alignment were the remains of a much earlier rectilinear enclosure. This survived only on three sides in the form of a V-shaped ditch 1.2 metres deep and 1.5 metres wide, which would have delineated an enclosure approximately 17.75 metres wide. Such rectilinear enclosures are difficult to interpret as few have been excavated and they are often incomplete because of damage caused by later ploughing. A similar enclosure at nearby Radley had a central grave and may have been the burial place of a prominent

A section through the Middle Neolithic enclosure ditch. (Reproduced courtesy of Oxford City Council)

individual. Alternatively, enclosures of this type may have been used as communal mortuary spaces for laying out the bodies of the dead to the elements in order to de-flesh the bones, a process known as excarnation. Whatever its function, the enclosure is the earliest monument yet encountered on the Oxford gravel terrace. A single animal bone, a sacrum probably belonging to a calf, found its way into the V-shaped ditch and produced a calibrated radiocarbon date of 3520–3360 BC.

Dating to the fourth millennium BC, the calf is likely to have had a hairy coat like an auroch as it would have had to survive out in the open without provision for winter shelter. Cattle were originally woodland creatures and were a logical choice for early domestication, being easier to manage than sheep in a heavily wooded landscape and providing greater returns in the form of meat and dairy foods, along with hides, horn and sinew. Here we have the earliest evidence yet for a domesticated animal reared by the semi-nomadic herders who on occasion called the Oxford gravel terrace their home. The date provided by this small piece of bone indicates that the rectangular enclosure built by this community had survived and therefore been respected in the landscape for perhaps a millennia and a half before the construction of a linear barrow cemetery over the top of it, no doubt with the intent of harnessing the powerful symbolism that it retained.

Dig 15

Chaucer's Red Hot Poker

Magdalen College Longwall Quad, 2012–14

In Geoffrey Chaucer's late fourteenth-century 'The Miller's Tale', John, an Oxford carpenter, works at Oseney Abbey and has a young and unhappy wife called Alisoun, a local beauty. She is bored with her life and has an affair with a College student who rents a room in their house. At the same time she is also coveted by a drunken parish clerk called Absalom. One night Absalom crosses the street to Alisoun's house inebriated and seeks a kiss through the darkness. His lips reach up to Alison's room only to encounter her bottom presented through the open window. In a rage Absalom crosses the street to the local forge and procures a hot poker. On his second visit, Alisoun's lover, the unfortunate student, gets an unpleasant surprise when he foolishly presents his bottom through the window. This ribald comedy by Chaucer was based on his familiarity with Oxford, a town where his son came to study.

Julian Munby has pointed out that there is documentary evidence for some of the background detail of Chaucer's tale. A number of carpenters lived along the eastern part of the High Street at this time and during the medieval period the town had two recorded blacksmiths' forges, one placed outside the Eastgate at the end of the High Street and the other outside the Northgate. These were located so as to keep them away from the densely packed wooden buildings along the main street frontages of the town. The precise locations of these two forges were never accurately documented.

In 2011 Magdalen College began an ambitious project to create a sunken library extension under and to the north of its existing library, a former Victorian school house, located on the corner of High Street and Longwall Street. Subsequently, a phased excavation between 2012 and 2015 directed by Ben Ford for Oxford Archaeology provided a rare opportunity to investigate the former street frontage plots just outside of the former Eastgate; the site was also of interest because the large walled precinct of the fifteenth-century College is known to encompass the sites of the former medieval Jewish burial ground and the medieval hospital of St John the Baptist.

The project was shaped by the need to protect the setting of the impressive College buildings and was challenging for a number of reasons. Firstly, the large fifteenth-century precinct wall along Longwall Street needed to be extensively underpinned before the sunken library could be built behind it in the Longwall Quad. Furthermore, archaeological trenching in the quad on the footprint of the new library extension in August 2011 had discovered the previously unrecorded medieval hospital cemetery. The subsequent planning consent for the library required that the impacted burials

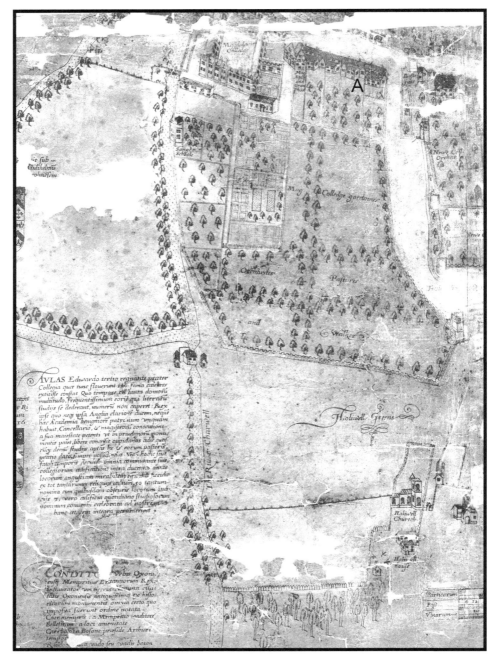

Part of Agas's map of Oxford, made in 1578 (south is at the top). The image shows the buildings that formerly occupied the site of the New Library at Magdalen College labelled 'A'. (Reproduced courtesy of the Oxford Historical Society)

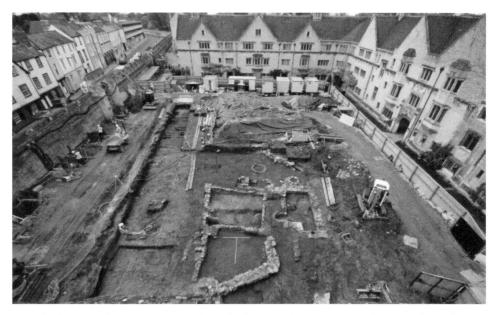

View looking north across Longwall Quad, showing the rear wings of post-medieval houses that formerly fronted onto Bridge Street (now High Street). To the rear of the quad on the left you can see grave cuts from the cemetery of the medieval hospital of St John the Baptist. (Reproduced courtesy of Oxford Archaeology)

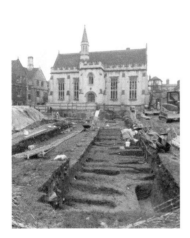
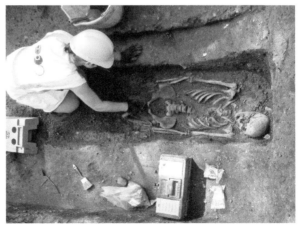

Above left: View of Longwall Quad looking south with grave cuts from the cemetery of the medieval hospital of St John the Baptist in the foreground and the college library to the rear. (Reproduced courtesy of Oxford City Council)

Above right: A well-preserved burial from the medieval hospital cemetery being investigated by Oxford Archaeology. (Reproduced courtesy of Oxford Archaeology)

be carefully excavated and recorded before being removed and was granted on the understanding that significant parts of the cemetery remain undisturbed within the quad.

St John's was effectively the general hospital of the town and the new library entailed the excavation of 118 burials from its cemetery. This was an exciting prospect as nationally such cemeteries have not been extensively excavated. Perhaps fewer than twenty comparable hospital sites, excluding leper hospitals, have been looked at by archaeologists, with many of these investigations only examining a small number of burials. Such sites can be rich sources of information about medieval life because they are often not subject to the endless re-cutting and intercutting of burials that is common in long-lived parish church cemeteries. At Magdalen College the burials did indeed prove to be well preserved with little intercutting of graves and future study of these skeletons may produce new data about the health and causes of death of the inhabitants.

The 2012 excavation in Longwall Quad, as well as examining the hospital cemetery, also revealed the remains of several medieval and post-medieval buildings that had been preserved under the College lawn just beyond the footprint of the College library. One tenement preserved an assemblage of artefacts belonging to the College barber and wig maker John Broughton, who leased the property in the late eighteenth century, including a deer horn-handled knife, common room wine bottles, a cut-throat razor and hundreds of ceramic wig curlers.

Returning in 2013–14 to excavate within the existing College library after the removal of the book stacks, the archaeologists discovered that below the floor of the former

A collection of eighteenth-century wig curlers that were recovered from Longwall Quad from within a tenement associated with the barber and wig maker John Broughton. (Reproduced courtesy of Oxford Archaeology)

Victorian school house the floors and hearths of the medieval buildings that had formerly fronted onto Bridge Street had survived. The survival of such street frontage remains is rare in urban locations because later cellars have often removed them. Unfortunately, there was an added logistical complication; the structural engineer for the development had established that when the nearby River Cherwell was high, water rose up through the Victorian foundations, making them vulnerable. Thus, not only did the site need to be dewatered, the floor of the library had to be excavated in separated strips so that the foundations would remain stable during the work. Oxford Archaeology and the main contractor, Stepnells, had to work closely together to keep the project to time.

After the dig comes the challenge of knitting together the stratigraphy; i.e. the layers of archaeology built up over time, strip by strip. The value of this painstaking work is to provide information about the size and layout of medieval properties in the small suburb outside Eastgate and how they were amalgamated to make larger tenements over time. At the east end of the library, below these medieval houses, there was a surprise

 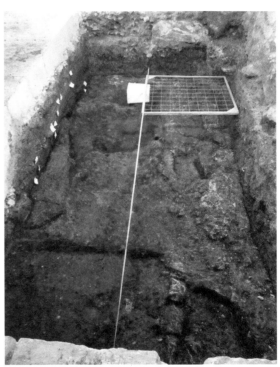

Above left: The interior of the New Library at Magdalen College with the book stacks removed. The building is dated to 1851 and was designed by John Buckler as a school house for Magdalen College School; it was altered in the 1930s by Giles Gilbert Scott to accommodate the College library. (Reproduced courtesy of Oxford Archaeology)

Above right: The remains of the likely medieval forge located below the footprint of the New Library. The building had thick stone walls and contained deposits of ash and slag. (Reproduced courtesy of Oxford Archaeology)

Ben Ford of Oxford Archaeology holding a piece of slag from the likely forge located below Magdalen College library. (Reproduced courtesy of Oxford City Council)

discovery in the form of a large Late Saxon ditch containing simple hand-made pottery and lumps of burnt daub, providing a rare glimpse of activity near to the Cherwell river crossing during this period. At the west end of the building the archaeologists uncovered the remains of a medieval building with thick stone walls, large stone-lined drains and evidence for smithing waste. This appears to be the Eastgate forge that Chaucer mentally mapped into his late fourteenth-century story as the source of Absalom's red-hot poker, providing the College with a link to a famous work of medieval English literature as some small compensation for a challenging development project.

Dig 16

Hugh Herland Was Here

New College Kitchen 2013–14

The economic decline of Oxford in the fourteenth century presented significant opportunities for wealthy patrons seeking to establish endowed colleges. In 1369 William Wykeham, Bishop of Winchester and Chancellor of England, began to buy land with the intention of founding a new college. The College of St Mary of Winchester in Oxford, which became known as New College, was the first Oxford College to intentionally adopt the quadrangular form and is likely to have been inspired by the unified architectural treatment of buildings with different functions located around the upper ward at Windsor Castle. It was conceived on a grand scale requiring the purchase of fifty-one tenements within the run-down north-eastern part of the walled town. The new buildings were built close to the thirteenth-century town wall and its bastions. A royal mandate of 1370 required the warden and fellows of the College to maintain and repair the wall in perpetuity and consequently the College contains the best-preserved section of the surviving medieval town wall. This part of the north-east quadrant of the town wall circuit is also of note for the presence of a now buried outer or concentric wall, probably added in the later thirteenth century.

The College was envisioned as a means of maintaining a supply of educated clerics into the Church at a time when other careers in trade and the military were tempting away young graduates, and it came with its own newly created feeder school at Winchester. The main College buildings were constructed between 1380 and 1390 under the direction of master mason William Wynford and master carpenter Hugh Herland and probably with input from master mason Henry Yevele. Wynford and Yevele were among the most successful English master masons of their era, both noted for their work in the Perpendicular Gothic style. Herland enjoyed a long career marked by royal works and is known especially for his hammer-beam roof at Westminster Hall, regarded as one of the great works of fourteenth-century carpentry.

An insight into the construction and operation of the medieval College was provided in 2013–14 when the College sought to refit and extend its fourteenth-century kitchen and buttery to cope with the demands of twenty-first-century student life. The refit required the installation of an additional extraction plant to comply with modern safety standards. This necessitated the lowering of the kitchen floor and removal of the wall plaster so that extensions and improvements could be targeted to avoid the primary fourteenth-century fabric. The ensuing archaeological project was managed by Ben Ford

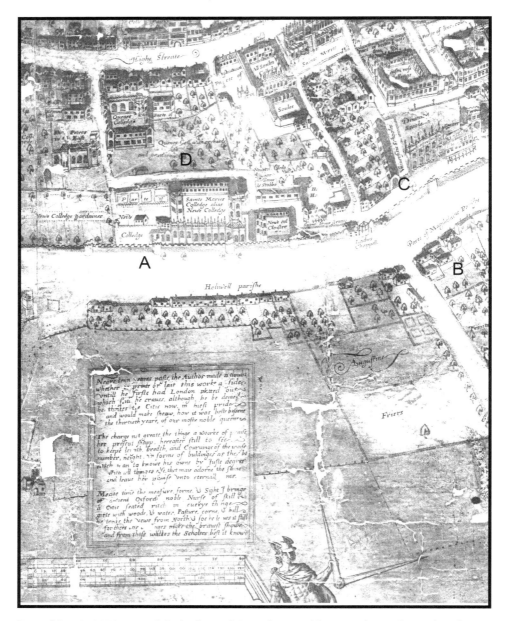

Part of Agas's 1578 map of Oxford (south is at the top). The map shows the medieval town wall at New College just north of the College kitchen 'A', the former houses on the site of the New Bodleian Library on Broad Street 'B', the line of the medieval town wall on the site of Clarendon Quadrangle 'C' and the location of the Queen's College Provost's Garden 'D'. (Reproduced courtesy of the Oxford Historical Society)

View looking south towards the medieval town wall at New College. The tiled roof of the fourteenth-century kitchen and its chimneys can be seen beyond with the taller and grander fourteenth-century College hall to the right. (Reproduced courtesy of Roland Harris)

View of the interior of the New College kitchen, showing central work tables and the cooking fire and range on the far side of the room. (Henry W. Taunt, 1901, reproduced courtesy of the Oxfordshire County Council Photographic Archive, HT8638)

for Oxford Archaeology and revealed a range of historic features that had been covered up by Victorian and later renovations.

These included the sites of hearths that would have supported spits for roasting and grates for cooking meals below the high open medieval roof and later keyhole-shaped ovens associated with the addition of chimneys to the structure in the Tudor period. The floor reduction also revealed thick deposits of medieval and post-medieval ash and kitchen waste that had been preserved beneath the twentieth-century concrete floor. By re-using the existing service runs that had been cut through the kitchen floor it was possible to leave the bulk of the archaeological layers in place. The archaeologists were able to sample these remains in order to obtain a picture of the range and quality of the medieval College diet.

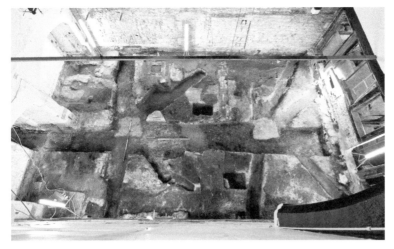

View of the excavated kitchen floor showing the previous service runs that were excavated for re-use and the thick ash deposits on the beaten floor. (Reproduced courtesy of Roland Harris)

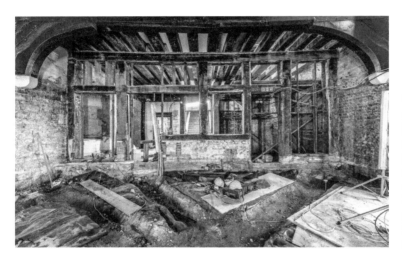

View from within the kitchen looking west at the fourteenth-century timber partition and the servery beyond, with central service hatches and a door opening to the left. (Reproduced courtesy of Roland Harris)

At the same time as the 2013–14 excavation was underway, building specialist Roland Harris undertook recording of the College buildings impacted by the works, including the ground floor kitchen, servery, beer cellar, hall and kitchen stairs and the pantry, buttery and attics above, all arranged to allow food to be served in the adjacent first-floor hall where the students still receive their meals.

New College retains a reputation for the quality of its choristers, who regularly perform and study in the fine fourteenth-century chapel. The College accounts record that, from its foundation, sixteen choristers were taken on to sing daily services. These boys were also required to serve in the kitchen and wait on the fellows who dined in the large hall. In return they received scraps from the kitchen and crude accommodation, an arrangement that persisted until the seventeenth century, when they were finally provided with an allowance for their labours and rehoused in the attic above the buttery.

The internal timber-framed single jetty of the first-floor buttery still juts out over the high-ceilinged kitchen. Below this the dividing wall between the kitchen and the servery was carefully exposed to reveal a configuration of mortice and tenon joints, allowing Harris to painstakingly reconstruct the original arrangement of serving hatches where the choristers must have laboured. The works also revealed hidden doors and fireplaces and allowed the investigation of Hugh Herland's original roof. The wall plates and rafter feet were recorded along with an intact arch-braced principal truss previously hidden behind the nineteenth-century east wall of the kitchen. A programme of dendrochronological sampling coordinated with specialist Dan Miles provided felling dates of the winter of 1382–3 and the spring of 1383 for the timbers of the buttery roof, floor and east wall. The work showed that floor joists reused in later repairs to the buttery roof were very probably derived from the hall floor, which was replaced in 1722, as these timbers were felled in the winter of 1387–8. The hall door was also shown to be of the late fourteenth century in date.

The project was an excellent example of how later College repairs and accretions can preserve important fabric beneath and how careful examination can provide information about how these buildings functioned. A final revelation was the uncovering of a series of large crude stone arches infilled with rubble in the east and west walls of the kitchen and buttery, and in the east wall of the chapel. These openings were inexplicable in terms of the grand fourteenth-century architecture of the College and appear to have been built to allow workmen to bring cartloads of materials backwards and forwards as this massive medieval building project was completed.

The eastern gable end of the fourteenth-century kitchen, showing the exposed infilled 'construction' arch below the removed plaster. (Reproduced courtesy of Oxford City Council)

Dig 17

The Prioress and her Flock

The Priory Hotel, Minchery Farm, 2014

When attempting to study and understand the lives of women in medieval society we are faced with a major obstacle in terms of the way the historic record has been shaped by authors of that time, who were usually men writing for a male audience. Where communities of relatively independent and empowered women existed, as was the case

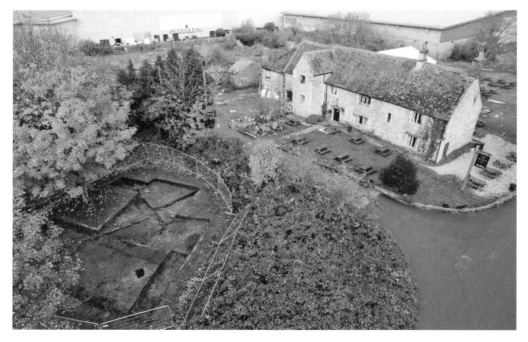

Aerial view of Littlemore Priory, showing the excavation of the western cloister by the East Oxford Community Archaeology Project (Archeox) in 2012. The surviving priory building (right) originally formed the eastern range of the cloister garth and would have contained the dormitory on the first floor, with the chapter house and other rooms on the ground floor. The building is fifteenth-century in date and was remodelled as a farm house in the early seventeenth century. (Reproduced courtesy of Adam Stanford, Aerial Cam)

with the approximately 150 nunneries established in England during the Middle Ages, these could be subject to a very negative commentary by contemporary chroniclers. For example, when the historian Eileen Power wrote her pathfinding paper 'Medieval English Nunneries' in 1922 she recounted the scandalous reports that had been made about Littlemore Priory, a Benedictine nunnery located 4.5 km south-east of Oxford. The early sixteenth-century Church records of investigations into the behaviour of the prioress and nuns at Littlemore paint a picture of lapsed morals and mischief that no doubt contributed towards building the case for reform. Subsequently, the priory was suppressed in 1525.

The report stated that the nuns 'played and romped [*luctando*]' with boys in the cloister, and individuals had illegitimate children and embezzled money. An earlier report of 1445 describes the poverty of the priory, which was then inhabited by seven nuns plus boarders. It notes that the dormitory was 'ruinous', so much so that the nuns feared to sleep there. An injunction was introduced by the Church authorities requiring nuns to sleep in separate beds and prohibiting Oxford scholars from visiting the convent. Power concluded that 'Littlemore Priory was in such grave disorder that it may justly be described as one of the worst nunneries of which record has survived'.

The remains of the nunnery can still be seen close to the Ozone Leisure Park on the Blackbird Leys Peripheral Road. Part of the fifteenth-century two-storey dormitory range of the priory survives, incorporated into a later farmhouse built around 1600. Of the surviving medieval fabric the most notable remains are a series of five small windows, some with trefoil tracery, spaced at regular intervals on the first floor of the east wall of the dormitory range. These are a characteristic feature of monastic dormitories, each window lighting a bed-space or cell. It is likely that a former open dormitory was replaced by cells or cubicles, each approximately 2.4 by 3 metres, when it was rebuilt in the fifteenth century, reflecting a wider trend within monastic cloisters where communal areas were reduced in favour of private spaces. These rather cramped conditions can be contrasted with Oxford's other, wealthier Benedictine nunnery located at Godstow to the north of the town, where archaeologist Roberta Gilchrist has suggested that the

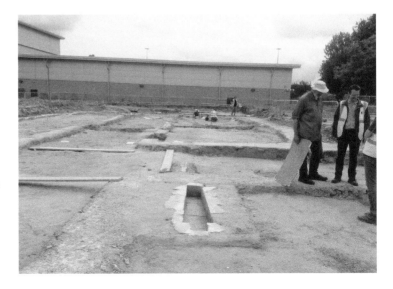

The Littlemore Priory church excavation looking east across the church footprint with the Ozone Leisure complex to the rear. The stone-lined cist in the foreground is located in the centre of the crossing. (Reproduced courtesy of Oxford City Council)

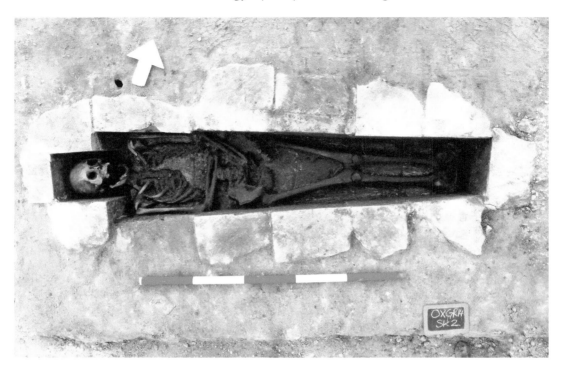

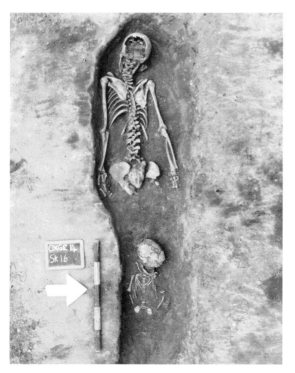

Above: A stone-lined cist burial located in a central position within the crossing of the church, possibly that of a prioress. (Reproduced courtesy of John Moore Heritage Services)

Left: An unusual prone (face down) burial of young woman with the body of a child inserted at a later date. The face-down position suggests some transgression and punishment as the body would not face east for the Resurrection; and yet, it was located within the priory church. (Reproduced courtesy of John Moore Heritage Services)

nuns may have been divided into households, perhaps reflecting aristocratic forms of domestic organisation.

In 2012 an excavation was undertaken at the Littlemore site by the East Oxford Community Archaeology Project (Archeox), which investigated the kitchen range of the priory cloister and discovered the likely site of a workshop area and high-status domestic building to the north, the latter perhaps the residence of the prioress. In 2014 a further excavation under the direction of Paul Murray for John Moore Heritage Services involved the excavation of over ninety burials associated with the priory church, preceding the construction of a new hotel.

Despite the best efforts of the archaeologists to promote a positive story about the lives of medieval women, the power of the sixteenth-century narrative reached across the centuries and a number of media outlets ran the story that the remains of 'sex crazed nuns' had been excavated near Oxford. Thus, the history books would have us believe that Littlemore Priory was a poor, immoral and badly run institution and in the end worthy of closure. Evidently this narrative still appeals to the popular imagination – but was this the reality?

The priory of St Mary and St Nicholas, originally part of the parish of Sandford and later that of Littlemore, was probably founded late in the reign of Stephen (1135–54), by Robert de Sandford, one of the knights of the Abbot of Abingdon. In 1239 Robert's son gifted the priory to the Knights Templar, who in 1240 established a preceptory nearby and may have injected funds into the priory at this time. The 2014 dig identified inconclusive evidence for a small rectangular twelfth-century church and more substantial remains of a church dating to the thirteenth century. Located within and around the church were burials belonging to the priory cemetery, including the remains of men, women and children. These remains belonged to distinctive groups of people associated with the priory: the nuns; the boarders who would have paid to stay at the nunnery and would have been an important source of income; and patrons who would have paid to be buried in the transept or side chapels of the church, where prayers would be said in their memory.

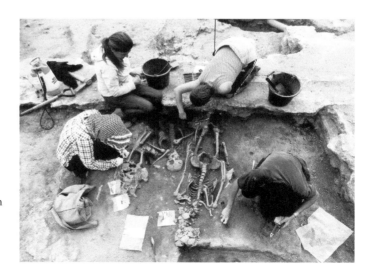

Burials being excavated from the cemetery of Littlemore Priory church. (Reproduced courtesy of John Moore Heritage Services)

A floor tile from Littlemore Priory with castle and fleur-de-lis motifs. The tile is of 'Stabbed Wessex' type (*c.* 1280–1330), so named because of the characteristic stabbed keying on the back. (Reproduced courtesy of John Moore Heritage Services)

The excavation offered a rare opportunity to examine the diet and health of the priory community and compare it to the tales of poverty and misadventure recorded in the history books. Of the bodies that could be identified, thirty-five were female and twenty-eight were male. The ages of the burials ranged from stillborn children to ages over sixty. In theory women would have had a greater chance of living longer in such an institution because as nuns they were avoiding the dangers of childbirth. At Littlemore 60 per cent of the female skeletons investigated were identified as over forty-five years of age, seemingly supporting this idea.

The study of the human bones by osteoarchaeologist Sharon Clough identified long-term ailments among some of the children, which could indicate that the priory may have had a role in caring for the sick. Generally the occupants were of average stature and there was a lack of indicators of disease, which suggests there was at least adequate nutrition and a reasonably healthy living environment. Further study by Charlotte Scull of Reading University involved isotope analysis of bone and teeth enamel, which can provide information about the character of an individual's diet. Nine skeletons were selected as possible nuns or religious women due to their location within the church and were compared to the likely patrons buried in the side chapel and north transept. Surprisingly the results showed that the nuns appeared to have richer diets, in terms of animal and marine protein, than male burials from the church who were likely to be wealthy patrons. The results indicated that the women of the priory at least were eating well and, not only that, were consuming a broad and varied diet. The exception appeared to be the possible prioress, who had been buried in a stone cist at the centre of the church. One might speculate whether either she lived in more difficult times or she was perhaps seeking to set an example to the other nuns.

Life in a nunnery could be an attractive option for wealthy parents with unmarried daughters who wished to find a cost-effective solution for their long-term support. Documentary evidence suggests that when daughters or nieces of patrons entered into nunneries they could sometimes be given special privileges not in keeping with the intended equality of nunnery life. This may be what we are seeing at Littlemore. Alternatively, the evidence from the skeletons may simply reflect that the nunnery enjoyed periods of relative prosperity and good management. Perhaps this was not 'the worst nunnery' of the medieval period after all.

Dig 18

The Secrets of the Orchard

The Queen's College, The Provost's Garden, 2015

Faced with the constraint of conserving the setting of their Grade I listed seventeenth-century library, the fellows of the Queen's College took a drastic decision that exemplifies the difficult choices facing such institutions located within the historic core of the city. The College required additional library space for its students and collections and took

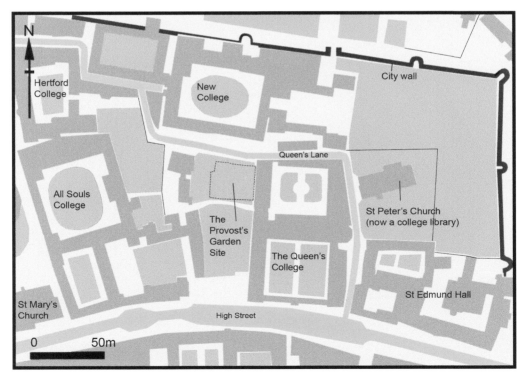

Plan showing the east end of the walled town and the location of the Queen's College Provost's Garden excavation. (Modified after R. Brown, 2015, Figure 1)

the decision to excavate the entire Provost's Garden adjacent to the existing library and place a new library extension underground. The garden was then re-established with a retained mature tree at the western end next to the old brew house, giving the impression that nothing much had changed, save for the discrete steps and glass light well rising up close to the original library.

Having been granted planning permission, the ensuing development presented archaeologists with an opportunity to investigate a sizable plot of land within the eastern part of the Late Saxon burh, located east of the line of the inferred earlier defences that may run roughly north–south through the middle of the University Church of St Mary the Virgin on the High Street (see Dig 2). The Provost's Garden excavation therefore provided an opportunity to discover whether Late Saxon activity here differed in character from other investigated parts of the burh.

The 2015 excavation by Oxford Archaeology under the direction of Richard Brown created a distinctive landscape of stripped archaeological site surrounded by monumental College buildings that was captured by the webcam on the roof of the Front Quadrangle. The site comprised a hotchpotch of quarry and rubbish pits that had been created during the use of this space as a garden and orchard for the College located south of Queen's Lane. The plot appears to have never been developed for housing in the medieval period and luckily, in between these later quarry pits, with their dark gravelly fills, were the surviving remains of a series of Late Saxon cellar pits and associated features. These features appear more reddish-brown in colour than the later pits, as they were dug and backfilled in the early years of the town when a post-glacial loess survived largely undisturbed across this part of the gravel terrace.

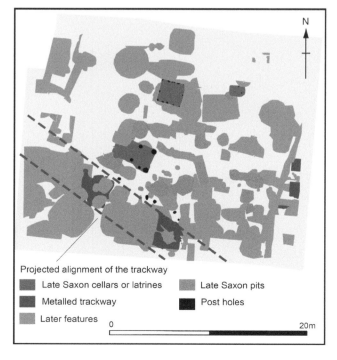

Projected alignment of the trackway

■	Late Saxon cellars or latrines	■	Late Saxon pits
■	Metalled trackway	■	Post holes
■	Later features		

0 20m

Plan showing excavated Late Saxon features at the Provost's Garden site. (Modified after R. Brown, 2015, Figure 3)

Three Late Saxon cellar pits and a row of post holes were found alongside a metaled trackway, which, given the survival of cart ruts showing the direction of travel, must have been orientated south-east to north-west. The trackway had the appearance of a number of other primary street surfaces seen across the Saxon town in that it was well made with rounded pebbles and gravel, in contrast to later street surfaces that have been shown to be made up of crude tips of gravel. Embedded in the earliest street surface was a goat or sheep bone that produced a radiocarbon date with a ninth to tenth century range. While the date is broad, the contextual evidence points to this being an early track along which later buildings were established. The Late Saxon features aligned on the track produced pottery suggesting activity in the late tenth and early eleventh century. Two of the nearby cellar pits contained post arrangements suggesting that there were wooden buildings above; the third did not have similar post hole placements and the soil samples taken from this feature contained deposits of cess, suggesting that it may have been used as a latrine. The site also produced finds of slag and furnace lining, hinting not just at the activity of Late Saxon blacksmiths, but at more specialised smelting and metalworking.

The excavation did not conclusively demonstrate that the eastern part of the Late Saxon town was only enclosed within a rampart after the creation of a smaller 'primary' burh to the west. The orientation of the track, along with the small size of the cellar pits compared to the examples from Cornmarket, both give the impression that this was a

View across the Provost's Garden, looking north-west during the excavation. (Reproduced courtesy of The Queen's College and Oxford Archaeology)

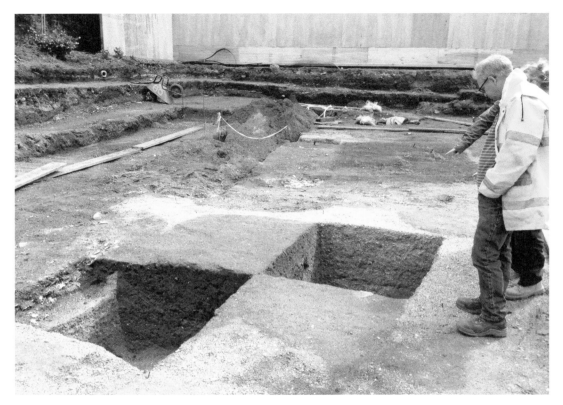

A Late Saxon cellar pit being excavated in the Provost's Garden in quadrants in order to capture the sequence of the backfilling. (Reproduced courtesy of Oxford City Council)

peripheral settlement along a track running from the crossing point over the Cherwell, near Magdalen Bridge, towards established northward routes along the gravel terrace and thus avoiding the more distinctive rectangular street grid of the Saxon town to the west. In light of the excavation results historian John Blair has suggested that the more rectilinear arrangement of the current Queen's Lane in the eastern part of town was not laid out until much later, perhaps in the twelfth century.

However, the Queen's College evidence does not provide a neat resolution to the question of how the eastern burh developed. Anne Dodd has pointed out that over 100 pieces of tenth-century pottery were recovered from the Provost's Garden excavation. If the defences of an earlier burh had been extended eastwards around suburban halls and huts as a result of specific Viking threats in the early eleventh century, it is curious that no discarded pottery from the settlement found its way into the rampart at nearby New College, which has been investigated on a number of occasions. Therefore, perhaps the eastern part of the burh defences were already built, or partly built, around this site before it became densely occupied. This view is supported by the recent recovery of optically stimulated luminescence (OSL) and radiocarbon samples from New College that point to a surprising eighth century date for parts of the buried rampart. Suddenly a story that seemed to be coming slowly into focus now appears more opaque.

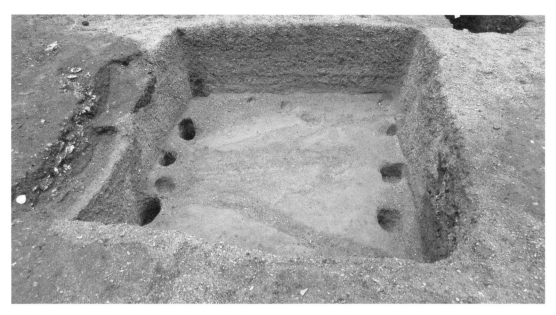

Fully excavated Late Saxon cellar pit in the Provost's Garden with an arrangement of post holes at the base. (Reproduced courtesy of Oxford City Council)

Part of a metalled Late Saxon track in the Provost's Garden with traces of cart ruts visible (parallel to the small square labels). (Reproduced courtesy of Oxford City Council)

Dig 19

Friar Bacon's Studium

The Westgate Shopping Centre, St Ebbe's, 2015–16

In 2015 archaeologists returned to the Westgate Shopping Centre and its car parks almost forty years after its completion to excavate more of the southern precinct of the Franciscan friary and make way for a much-expanded shopping centre and underground car park. It was recognised at an early stage that the friary's status as a studium generale for the Franciscan Order linked to notable medieval scholars such as Robert Grosseteste and Roger Bacon made it a special site that would require considerable resources to record properly. The complex recording project that followed at the 4-hectare site resulted in the biggest exposure of medieval structures yet seen in Oxford and the recovery of a large collection of finds, including leather and wooden objects that had been preserved by the oxygen-free environment of the floodplain.

In 1244, not long after the town wall had been substantially rebuilt, King Henry III gave the Greyfriars permission to expand their precinct south across the line of the wall down to the Trill Mill stream. They subsequently acquired the island south of the mill stream known as Boteham and the grounds of the Friars of the Sack to the west,

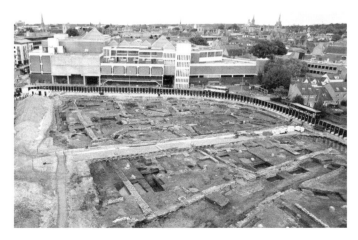

Aerial view of the Westgate excavation looking north, showing the exposed Franciscan friary buildings, including the precinct wall and the stone-lined Trill Mill Stream channel at the bottom right of the picture. (Reproduced courtesy of Oxford Archaeology)

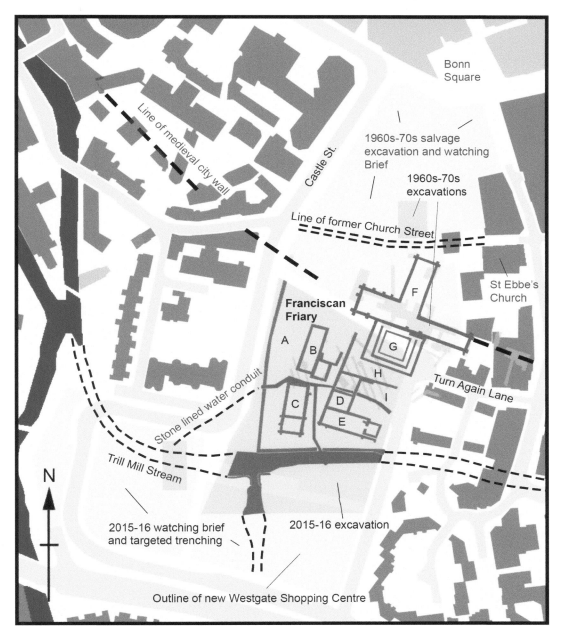

Plan of the 1967–76 and 2015–16 excavation areas at the Westgate site, St Ebbe's. The layout of the Franciscan friary is shown. Key: A = kitchen yard; B = bake house, kitchen and servery; C = refectory; D = dormitory and reredorter (latrine); E = infirmary and small chapel; F = north nave of the friary church; G = main cloister; H = southern range library[?]; I = minor cloister. (Modified after Hassall et al., 1989, and Oxford Archaeology site display)

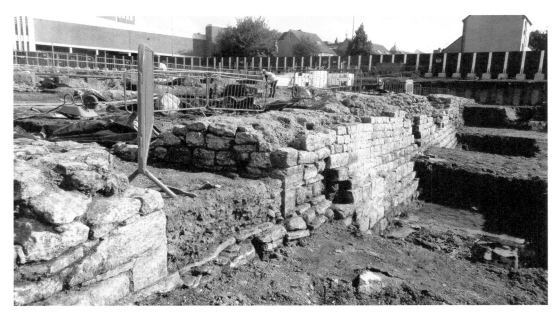

The well-built southern part of the friary precinct wall with an opening where the friary's water conduit emptied into the Trill Mill Stream. (Reproduced courtesy of Oxford City Council)

A medieval book clasp of likely fifteenth-century date from the Westgate site inscribed with the letter M. (Reproduced courtesy of OxfordArchaeology)

creating a substantial land holding. This included an impressive garden and orchard that came to be known as 'Paradise', a common name for medieval gardens. The extension of the precinct southwards involved the reclamation of a large area of land from the floodplain. The new precinct and its grand church drew criticism from older friars, who held on to the humble aspirations of the founders and frowned upon the 'stately and magnificent' convent that was growing up around them.

Over the course of the 2015–16 dig the lost landscape of the Franciscan friary was revealed. The well-built precinct wall was exposed. This must have taken over the role of the town wall and a particularly thick section fronting onto the Trill Mill stream may have formed part of a wharf for unloading supplies. The system of stone conduits that provided running water to the friary was also extensively investigated, revealing a well-preserved wooden sluice gate for controlling the flow of water into the friary latrine and mill stream. The sludge at the bottom of the conduit itself proved to be a rich source of finds as it had survived later disturbance, which many of the walls and floors at a higher level had not.

Another area that miraculously had escaped later disturbance was the kitchen bake house and nearby waste pits in the kitchen yard, the former preserving the bases of multiple ovens and floor deposits, including thick layers of ash and food waste. Elsewhere the friary layout could be interpreted in comparison to other contemporary sites with foundations identified that are likely to belong to the dormitory, hospital, latrine, refectory, main cloister and minor cloister. To the south of the old Trill Mill stream, side channels were found heading south across the floodplain, in places retained by massive oak planks. Large wooden sluices appear to have controlled the flow of water into these channels, perhaps to fishponds to the south.

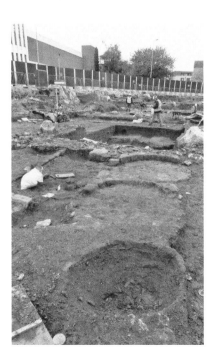

Round ovens from the friary bake house and kitchen complex. (Reproduced courtesy of Oxford City Council)

The ground reduction required for the double basement at the southern end of the friary enabled the archaeologists to excavate and record the various thirteenth-century building techniques that had been employed to create stable foundations in the wet conditions of the floodplain, including sprung reliving arches, packed gravel trenches and over 2,000 waterlogged pieces of timber that were sharpened to a point and driven into the ground as foundation piles. When the archaeologists came to investigate the timbers they discovered that a significant number were re-used medieval building timbers. Notable timbers included three upright octagonal posts with mortice joints on two sides, which may have belonged to a rood screen from a medieval church.

Retrieving and recording these timbers as well as retaining particular interesting examples for freeze drying in order to secure long-term preservation were among the many logistical challenges faced by Ben Ford, who directed the Westgate dig for Oxford Archaeology. Other challenges included keeping a functioning bus route running through the middle of the dig as it progressed and meeting the requirements of the city council for an extensive public outreach programme. With fortuitous timing, Oxford Archaeology had just issued its senior project officers with aerial drones. This new kit was used to good effect, capturing the dig from the sky and enabling the production of a three-dimensional computer model of the site, which was made available on the internet. The public outreach element of the project involved pop-up museums featuring finds from the dig staffed by enthusiastic local volunteers, a programme of filmed public talks that were made available online, well-attended open days, extensive press coverage and projects with children from local schools. The project was subsequently awarded the Best Archaeological Project Award at the British Archaeological Awards in 2016.

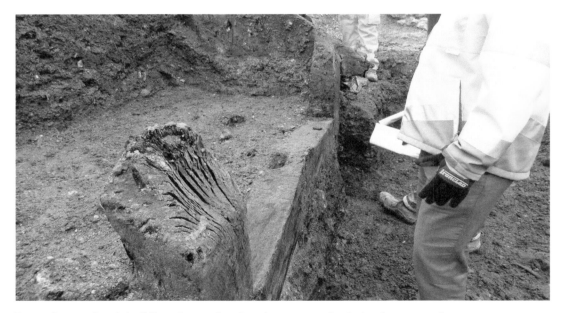

Part of a medieval building frame that has been re-used wholesale as wooden support to stabilise the built-up ground adjacent to the Trill Mill Stream. (Reproduced courtesy of Oxford City Council)

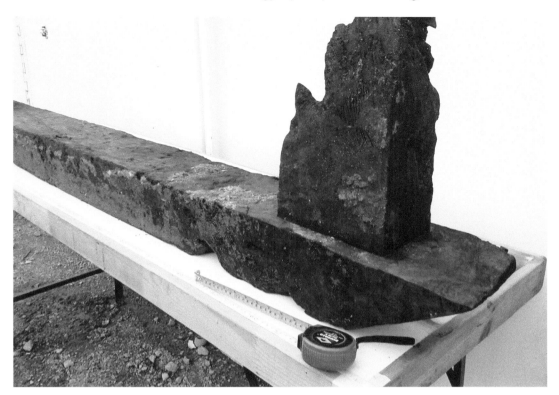

Above: One of the wooden sluice gates from the friary's stone-built water conduit. Originally the conduit was lined with lead, but this was removed soon after the closure of the friary in the sixteenth century. (Reproduced courtesy of Oxford Archaeology)

Right: A carved medieval octagonal oak pillar shaft with vacant mortice joints on two sides. This was one of three recovered from the Westgate site that may have belonged to a rood screen from a church or chapel. The re-used timbers had been sharpened at one end to allow them to be driven into the floodplain as piles in the thirteenth century. (Reproduced courtesy of Oxford Archaeology)

The excavation also provided an opportunity to understand the development of the Trill Mill stream from a Holocene channel at the base of the second gravel terrace through to a fast moving Norman stream and subsequently a canalised stream running through the grounds of the friary and powering an as yet undiscovered mill. Ford believes that the mill was probably located outside the shopping centre footprint further to the east. The stream was eventually culverted in the Victorian period and was redirected through a new culvert as part of the new development.

The project also investigated a range of other features across the extensive development footprint. A small number of isolated pits and boundary ditches, belonging to the Late Saxon and Norman landscape that was sealed below the friary reclamation layers, were recorded. Other excavated features included the wet ditch that formed the southern line of the Royalist Civil War defences and the remains of houses and waste pits belonging to the 1820s suburb of St Ebbe's.

As the open area excavation drew to a close, last-minute discoveries included burials associated with the friary church that were left preserved in situ below the new foundations and part of a tiled pavement from the corner of the main cloister. This was made up of decorated glazed floor tiles of a type known as 'Stabbed Wessex' that can be dated to the late thirteenth or early fourteenth century. With funding from Historic England and the developer Land Securities, the tiled floor has been put on display within the re-opened shopping centre. Given the known production dates of these tiles one could imagine an ageing Roger Bacon (*c.* 1214–92) walking quietly over them, engaging in deep thoughts concerning the study of light, music, alchemy and the heavens.

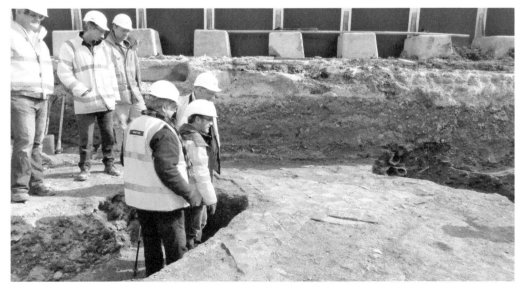

A tiled pavement from the corner of the friary cloister being examined by the Westgate Archaeological Advisory Panel. The tiles are of Stabbed Wessex type (*c.* 1280–1330) and are now redisplayed within the Westgate Shopping Centre. From right: Tom Hassall; Ben Ford (OA Senior Project Manager); George Lambrick; Ben Atfield (OA Project Officer); Myk Flitcroft (Archaeological Consultant) and Julian Mabbitt (Land Securities). (Reproduced courtesy of Oxford City Council)

Dig 20

The Lost Barrier?

St John's College, The President's Garden, 2016

In 1642, after being forced out of London by the rise of pro-parliamentary feeling, King Charles I moved his court to Oxford, where he established his military headquarters for the ensuing Civil War. The outcome of this decision can be seen in subtle markers in the townscape, the most tangible of which are the remains of two lines of defensive ramparts and ditches built around the city between 1642 and 1646. The first ramparts were built by enthusiastic Royalist students and subsequently by forced conscription, the King requiring one day's labour a week from the able-bodied men of the town, resulting in resentment and attempts of sabotage from the more Parliamentarian-leaning townsfolk. When the town fell to Parliamentary forces commanded by Sir Thomas Fairfax in 1646, much of the defensive ditch was filled in and the rampart slighted; however, some earthworks survived north of the town.

One surviving stretch of the rampart either side of Mansfield Road has been increasingly hemmed in by unsympathetic development. In 2014 a scheme by New College for a new music practice room presented an opportunity to reverse this trend and bring this section of the Royalist rampart at least partly back into the public realm by opening up a view of it from the road. It also presented an opportunity to investigate the make-up of the earthwork and led to a surprising discovery.

In 2003 David Sturdy (1935–2015), a former Assistant Keeper at the Ashmolean Museum (1958–66), published a book called *Historic Oxford*, in which he suggested that north of the town a large Late Saxon defensive ditch might have been built across the gravel terrace between the Thames and Cherwell rivers, which could be traced in surviving field boundaries and hints in documentary sources. At the time this idea was not widely accepted as no concrete supporting evidence was provided. This changed in 2014 when the small trenches excavated by Oxford Archaeology through the Royalist rampart west of Mansfield Road at Savile House revealed that the rampart in this location, comprised of up-cast gravel, had been added to a large bank made up of redeposited reddish loam derived from the terrace loess. An OSL date obtained from the tail of the feature produced a surprising date range from between the ninth and eleventh century for the earlier bank. The immediate response of local archaeologists was cautious. Perhaps the bank was an agricultural feature or field bank, rather than some kind of an outer defence for the town, for which there would be no close parallel during this period?

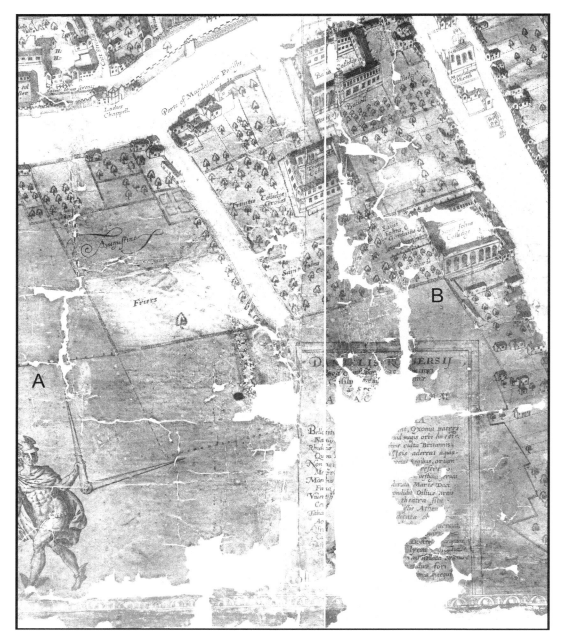

Part of Agas's 1578 map of Oxford (south is at the top). The boundary labelled 'A' aligns with the Civil War rampart at Savile House and the northern boundary of the precinct of the Austin friary, which was founded in the thirteenth century. This boundary appears, perhaps fortuitously, to align with the boundary west of Parks Road (formerly known as Beaumont Street), which forms the parish boundary of St Mary Magdalen and St Giles, labelled 'B', the line of which is also followed by the large ditch recorded in 2016 at St John's College. (Reproduced courtesy of the Oxford Historical Society)

The Royalist rampart in the grounds of Savile House on Mansfield Road before the completion of the proposed landscaping scheme. (Reproduced courtesy of Oxford City Council)

Excavation of part of the reddish loam bank that lay partly beneath the gravel up-cast of the Royalist rampart in the yard of Savile House, Mansfield Road. (Reproduced courtesy of Oxford Archaeology)

Looking south-west along the northern elevation of Canterbury Quad, St John's College, showing the excavation of a large east-west V-shaped ditch in the President's Garden in 2016. (Reproduced courtesy of Oxford Archaeology)

A few years later, in 2016, St John's College, located further west on St Giles, decided to extend their grand seventeenth-century library northwards from Canterbury Quad into the President's Garden, thus crossing over the possible east–west line of Sturdy's hypothetical earthwork. The site was excavated by Oxford Archaeology under the direction of Carl Champness and initially revealed only pits and ditches associated with medieval and later settlement to the rear of St Giles. However, in the last week of the project a large ditch was encountered running for at least 30 metres east–west across the site. This began as a steep-sided V-shaped ditch 2.4 metres deep and at least 3.4 metres wide and was subsequently recut by a U-shaped ditch 4–5 metres wide. Moreover, Late Saxon to Early Norman shelly ware was recovered from the first U-shaped recut of the ditch. A radiocarbon date obtained from charcoal recovered from the recut indicated the ditch had been open in the twelfth century. Furthermore, both the Mansfield Road and St John's features appear to align with a boundary on Agas's sixteenth-century map of Oxford.

Thus the presence of a massive ditch and perhaps an associated bank crossing the gravel terrace east to west, potentially linking the Thames and Cherwell rivers, is now a distinct possibility. It would be perhaps premature to seek to explain these discoveries before the archaeological results have been fully published. It is not inconceivable that the loam bank and V-shaped ditch form part of a monument or monuments that originated as prehistoric or Saxon features in the landscape and that were re-used as later boundaries. Although at the time of writing the available radiocarbon and OSL dates from Savile House do not allow a clear chronological sequence to be proposed, Sturdy's suggestion could yet be proved right: that the two features form part of an outer defence added to the burh in the late tenth or eleventh century during a period of heightened Viking threat, perhaps similar to the Hounds Ditch added to the defensive circuit around London in the same period.

Unfortunately, Sturdy did not live to see his theory revived. Nevertheless, the rediscovery of these large features, for centuries hidden by domestic and College gardens, has added more remarkable assets to Oxford's rich historic landscape. As is often the case with such new discoveries, we are presented with a whole new set of questions to answer. Did a bank and ditch run right across the terrace between the two rivers? If so, was it built to defend Oxford from Viking attack? What was the significance of the space between this line and the defended town to the south? Who built it?

Acknowledgements

The author would like to thank the following people and organisations for permission to use copyright material in this book: The Ashmolean Museum, Brian Durham, the fellows of Brasenose College, Museum of London Archaeology, the National Portrait Gallery, Oxford Archaeology, Oxford City Council, Oxford Historical Society, Oxford History Centre, John Moore Heritage Services, Adam Stanford/Aerial Cam and Thames Valley Archaeological Services.

I am grateful to Anne Dodd, Brian Durham, Roland Harris, Tom Hassall, George Lambrick and Julian Munby for providing comments on the draft. I would also like to thank Tim Braybrooke, Richard Brown, Carl Champness, Ben Ford, John Moore, Paul Murray and Steven Yeates for providing information on digs 14 to 20 in advance of publication. Any mistakes or misrepresentations in the text are entirely my own. My love and appreciation go to Steph, Annabel, Jeanette, John and Irene for their help and support. I would also like to extend my thanks to Connor Stait, my supportive commissioning editor.

Full publication references for modified plans and sections are provided in the captions unless the reference is cited in the select bibliography, in which case a shortened reference is provided.

Select Bibliography

A number of the excavations discussed in this book are published in the journal of the Oxfordshire Architectural & Historical Society *Oxoniensia*, which is available online at http://oxoniensia.org (Dig 3 (Vol. 4), Dig 4 (Vol. 23), Dig 5 (Vols 34–38, 54) and Dig 9 (Vol. 66)). Digs 2, 6 and 8 are published in Dodd (2003) below.

Anon, *Archaeologia Oxoniensis* 1892–95 (1895), pp. 7–14.

Blair, John, *Anglo-Saxon Oxfordshire* (2nd edn, Sutton Publishing, 1998).

Braybrooke, Tim, 'Oxford University: Radcliffe Observatory Quarter: Radcliffe Infirmary Site, Oxford, Post-Excavation Assessment' (Unpublished Museum of London Archaeology Report, 2011).

Brown, Richard, 'Provost's Garden: The Queen's College, Oxford, Post-Excavation Assessment' (Unpublished Report, 2015).

Chadwick, Adrian *et al.* (eds), *Quadrangles Where Wisdom Honours Herself: Archaeological Investigations at Tom Quad Peckwater Quad and Blue Boar Quad, Christ Church, Oxford* (John Moore Heritage Services, 2012).

Dodd, Anne (ed.), *Oxford Before the University* (Oxford Archaeology, 2003).

Hassall, Tom G., 'Archaeology of Oxford City' in Briggs, G. *et al.*, *The Archaeology of the Oxford Region* (Oxford University Department for External Studies, Oxford, 1986), pp. 115–34.

Jeffries, Nigel *et al.*, 'Development of the Former Radcliffe Infirmary, Oxford, 1770–1900' (*Post-Medieval Archaeology*, Vol. 49, Issue 2, 2016).

Lambrick, George, 'Thames Floodplain Survey' (CBA Group 9, Newsletter 13, 1983), pp. 147–8.

Lambrick, George, 'Prehistoric Oxford' (The Tom Hassall Lecture for 2012, *Oxoniensia* LXXVIII, 2013), pp. 1–48.

Lambrick, George and McDonald, Alison, 'The Archaeology and Ecology of Port Meadow with Wolvercote Common' in G. Lambrick (ed.) *Archaeology and Nature Conservation* (Oxford University Department for External Studies, 1985).

Little, Andrew G., *The Grey Friars in Oxford: Part I: A History of Convent, Part II: Biographical Notices of the Friars, Together with Appendices of Original Documents* (Oxford Historical Society, 1892).

Mellor, Maureen, *Pots and People that Have Shaped the Heritage of Medieval and Later England* (Ashmolean Museum, 1997).

Pollard, A. M. *et al.*, '"Sprouting Like Cockle Among the Wheat": The St Brice's Day Massacre and the Isotopic Analysis of Human Bones from St John's College, Oxford' (*Oxford Journal of Archaeology*, Vol. 31, Issue 1, Feb 2012), pp. 83–102.

Power, Eileen, *Medieval English Nunneries c. 1275–1535* (Cambridge University Press, 1922).

Preston, Jamie, 'Grandpont Causeway Archaeological Recording' (Unpublished Jacobs Babtie Report, 2005).

Pullman, Philip, *Lyra's Oxford* (David Fickling Books, 2003).

Sturdy, David, *Historic Oxford* (Tempus, 2003).

Scull, Charlotte March, 'Diet and Lifestyle at Littlemore Nunnery Preliminary Carbon and Nitrogen Stable Isotope Analysis' (Unpublished Interim Report, 2016).

Wallis, Sean, *The Oxford Henge and Late Saxon Massacre; with Medieval and Later Occupation at St John's College, Oxford* (Thames Valley Archaeological Services Monograph, Vol. 17, 2014).

Yeates, Steven and Murray, Paul, 'Report on Archaeological Recording at The Priory, Grenoble Road, Oxford' (Unpublished Report, John Moore Heritage Services, 2016).

For further extensive references for archaeological fieldwork in Oxford, see the online Oxford Archaeological Plan, available online at https://www.oxford.gov.uk/info/20200/archaeology.